Dreams in Dry Places

The Great Plains Photography Series

DREAMS IN

University of Nebraska Press

Lincoln and London

DRY PLACES

Roger Bruhn

Foreword by Ted Kooser

Notes by Edward F. Zimmer

This volume in
the Great Plains Photography Series is
made possible by a grant from
the University of Nebraska Foundation
to extend the work of
the University beyond its campuses.

'
The paper in this book meets the min-
imum requirements of
American National Standard for
Information Sciences – Permanence of
Paper for Printed Library Materials,
ANSI Z39.48–1984.

Library of Congress
Cataloging in Publication Data
Bruhn, Roger, 1941-
Dreams in dry places.
(Great Plains photography series)
Includes bibliographical
references and index.
1. Photography – Landscapes.
2. Nebraska – Description and travel –
1981- – Views. 3. Bruhn, Roger,
1941- . I. Title. II. Series.
TR660.B784 1990 779'.4782'092
89-14680 ISBN 0-8032-1214-3

To my three girls, Lynne, Mollie, and Whitney

CONTENTS

FOREWORD

Ted Kooser

I once met a man who had been brought up and educated within the walls of a great estate in Ireland. His name was Robert. The family was English and Protestant, and thus isolated from the surrounding Irish Catholic culture. In an attempt to educate his son, Robert's father, an architect, had brought in workers to construct elaborate "follies" in various corners of the grounds. These were the settings for the father's daily lectures.

A folly is more than mere foolishness: architectural follies were once taken very seriously and were built at considerable expense. On Robert's family estate there was, for example, a folly that resembled one corner of a classical ruin, with tumbled and broken Doric and Ionic columns overgrown by vines. This was the setting for the father's lectures on Greek and Roman antiquity. Other follies—part of a medieval chapel, the thatched hut of a crofter, a small stone turret—provided the backdrops for lectures on religion, agriculture, history, literature, and the arts. The father taught by drawing the boy's attention to the representations before him, and the child's education proceeded from there.

However eccentric may seem the sequestered life and education of this child, he grew up to be a gregarious and charming man. By offering his close attention to the follies before him in that elaborate garden, he learned a great deal about the world beyond the walls—walls of stone, of course, but also of time. He learned to be attentive to things before him, and he had developed a lifelong habit of being keenly aware of wherever he happened to be. For a column made of chicken wire and plaster of Paris *can* stand for the glory that was Greece and the grandeur that was Rome.

Dreams in Dry Places is the record of Roger Bruhn's response to another garden and another time. His garden is the Great Plains, sparsely set out with its own follies. Like Robert, Roger has learned to observe and to carry his camera with him wherever he travels. His photographs testify to his enthusiasm for and awareness of this special garden, filled as it is with architectural creations of another sort, built for other purposes, but from which Roger has learned and from which we can learn as well.

Robert's story is of special interest to me because I have always been fascinated with the idea of architecture as backdrop, as setting, as scene—less as something that contains life and

shelters it and more as something we stand be-
fore to learn from and to be measured by. Each
building becomes a metaphor for its builder's
perseverance, frugality, creativity, patience, and
dream. For the things we build define us. Often
they give away our secrets. The follies on Rob-
ert's estate tell us much about his father, just as a
tiny Neoclassical street-corner bank in a small
town in Nebraska can tell us a great deal about
its architect, as well as about the rather stuffy
and inflated dream of the banker who paid him.

We have plenty of small follies on the Great
Plains, and we've all seen them: the white iron
bathtubs set upright in front yards to shelter plas-
ter Virgins in blue enameled robes; wind-driven,
spinning bicycle wheels with foil meat-pie pans;
birdbaths made of broken Fiesta pottery stuck
gaily into thick mortar; miniature Dutch wind-
mills; and dry fishpools, full of dead leaves,
spanned by miniature Japanese bridges badly
needing paint. Without ever meeting them, we
know the playful people who erected these
things.

We have big follies, too. In the little town of
Garland, Nebraska, there happens to be an
abandoned movie house called "The Folly." It's
a one-story brick building now used for storage.
Its windows are broken out and the paint on its
doors has peeled away. Sparrows and field mice
have taken over The Folly, whose name is redo-
lent of irony and whose owner's dreams of suc-
cess were as foolish as foolish can be.

In the long sweep of time, all buildings, it
seems, are follies—foolish attempts at perma-
nence, set up as backdrops against which we
live out our lives. Vainly we build them up and
paint them up, and sooner or later the paint
peels off, the roof caves in, and the walls fall all
to pieces. "All the world's a stage," wrote
Shakespeare, and after looking at some of the
photographs in *Dreams in Dry Places* it occurs to
me how much like stage sets are the main streets
of small towns across America, with those im-
posing storefronts hiding collapsing wooden
sheds. When touring the Hollywood movie lots,
we may smile to see the rows of buildings along
a standard "Main Street" with nothing behind
their realistic fronts but two-by-fours and air. But
are these really that far removed from the "sets"
back home?

Where there is folly, there may be failure; and
where there is failure, there is always sadness.
There is something melancholy about buildings
like the Folly Theater in Garland. A dream lived
there. A dream still lives there; it is easy to feel.
And though dreams themselves are invisible,
they do cast shadows, long shadows, sometimes.
This book is full of those shadows.

A dream has tremendous endurance, and we
know that somehow a dream can survive, no
matter what the weather does to a pine board or
an asphalt shingle, no matter that the highway
department relocated the road, no matter that
the railroad pulled up its tracks and sold off its

ties and went out of business forever. In this book you can see those dreams, indefatigable in their poor clothing of frail wood, or cake-soft brick, or concrete made from little more than fickle, shifting sand. Some of those dreams are simple ones—dreams of shelter and warmth. Others are more complex, more abstract: the dreams of worship, the dreams of government, the dreams of commerce.

Although in this book the dreams wear building stone and clapboards, it would be a gross oversimplification to say that the subject of *Dreams in Dry Places* is architecture. Although architectural images do predominate and provide a concrete and unifying metaphor for Bruhn's vision of the course of human aspiration, this book is much more than a collection of photographs of buildings. The title of the book comes from the writing of Wright Morris, another photographer, and, by good fortune, the title of one of Morris's other books has further application here: *The Field of Vision. Dreams in Dry Places* is a record of its maker's field of vision. A Zen master might tell us that one can learn from concentrating on anything. Roger Bruhn draws his wisdom and his understanding of dreams from closely observing buildings, just as our Irishman, Robert, learned from studying his father's follies.

Taken on its own, architecture can be a pretty dull subject. In this book, though, architecture is the unifying metaphor for the photographer's field of vision, his world-view. But because the architectural metaphor predominates, it may serve us to offer the science of architecture some brief consideration.

The architecture that stands behind and sets off our lives is often predictably uniform. Buildings within a specific historical period take on the fashion of that day. "Send a fool to close the shutters and he'll close them all over town," goes an old Yiddish proverb. The motive behind adherence to fashion, of course, in architecture as well as in dress, is the quest for acceptability. And acceptability in any activity is often the lowest common denominator. For this reason, a popular style of architecture—take the "ranch house," for example—is (dare I say?) uninspiring. Only after time has torn down ninety-nine percent of those ranch houses filling our suburbs will the remaining few be discovered to be "quaint" and of some historical interest.

Materials, too, have a homogenizing effect on architectural fashion. Where there is stone in abundance, stone buildings are erected. In Nebraska, where there is little accessible stone, most of our buildings are of wood. (What few stones we find in our fields are sometimes celebrated—whitewashed and placed along a driveway up to a house, or set like the crown jewels around a washtub full of geraniums; we even sell "landscape boulders" at our garden stores!) Choices of material, and of design, are generally rational, practical choices, and the buildings built upon those choices are rational and practi-

cal in appearance: What will fit on this lot? How big does it have to be to fulfill its purpose? What can we afford to use for materials?

But what sets some buildings apart from others is more than nonconformity of design or eccentricity in choice of materials. Call it a trace of madness or (to be more polite) of genius, this genius for making form and function add up to more than the sum of its parts. And in standing before these special, transcendent buildings one often feels an unmistakable sense of joy, even of hilarity. For example, I defy anyone to walk through the Nebraska State Capitol without exhilarating in the fine madness of its architect, Bertram G. Goodhue.

Any tour guide who knows architecture can point out buildings for us to look at. Sometimes, though, we need to have someone to help us in *seeing*. We need someone pointing back into the shadows of those follies. We need to have someone direct our attention up into the shadows under the lip of the roof where the gargoyle is laughing. Look, for example, at Bruhn's photograph of the grain elevator in Hastings (no. 41). A great part of his success in portraying this stark building has been in finding and communicating its fine madness—a sort of wild, cyclopean monomania. Looking at this photograph, which frames and lights the elevator in just this special way, no one can fail to feel the dream that stands there, big and tall and just a little crazy. Or look at the photographs of the Wertz barn

(no. 10), with its hint of the evangelical, and of the slightly cockeyed Tecumseh city hall (no. 39), in which Bruhn has shown us both the wildness and the genius.

For these telling images we can thank Bruhn's keen way of looking hard at things. Of all of the photographs he's made, he has selected only those images that really count for something.

You'll notice basic organizing principle. As the book opens, we see the barrens from which all aspirations rise—a scene from Genesis, perhaps—and as it closes, we see the dust to which all human endeavor will one day return. And in between, with their cedar clapboards turning to silver, are arrayed the dreams in this dry place, Nebraska.

You'll discover that Bruhn has carefully arranged these dreams in a fugue of images. This works in many ways. For example, as buildings appear in the early pages, they gradually begin to assume more and more of the image area until they become the dominant feature of each exposure. Then, with the side-by-side appearances of the Dane Church and the Wertz barn, we see the introduction of a sort of point-and-counterpoint. Like the good teacher Robert's father was, setting the Doric column against the Ionic, Bruhn has set one image off against another, thus accentuating their contrasts. Throughout the book, this comparison of images provides not only an organizing principle but a theme.

Another movement in the book is from the ru-

ral to the urban. Just as the earliest images are of barrens, followed by habitations upon those barrens—the natural course of settlement—later we have the movement from rural to urban, with the isolation of rural buildings giving way to the growth of towns and then cities. And just as aspiration on the Great Plains can be represented by the erection of tall buildings in defiance of the oppressive leveling of the horizon, Bruhn follows the introduction of his urban images with the introduction of the height of aspiration, of dream, the tower.

These are the obvious organizational elements, but there are others, more subtle, more elusive. Note, for example, how the light at particular times of the day unifies certain consecutive images, and how others are brought together by architectural style. Note how the interiors play upon one another. This is not just a collection of photographs; it is a book with an architecture of its own.

Just as ranch-house architecture can be boring, we all know, the everyday photography of buildings can have its own dreary predictability. We've all seen the pictures of bank buildings and insurance companies on their free calendars. At the most, in such pictures one learns to expect a cool, professional detachment and a sort of pedestrian respect for the subject. Most often that respect is for stability; we want our banks to look so heavy that they can't be carried off. In such pictures there is little attempt to evoke the

spirit of the person who designed the building, or of the people who occupied it and who once stood before it to claim it for their own.

Roger Bruhn would call this detached method "architectural photography," and would point out that at best its motive is the glorification of the architect. Less respectful, I would call this the photography of shells—seashells, really, like those dried-out and irretrievably empty and displaced conch shells that people on the Great Plains like to set in the borders of their flower beds to prove that the owner has in fact been elsewhere in the world. (How empty they are! Though by holding one up to your ear you may be able to hear the sea-whistle of your own blood coursing, you'll never, ever, hear the laughter of another human being.)

Other contemporary photographs of buildings show a more profound understanding of the context of their subject. The fashion in taking these pictures follows the precedent set by some of the photographers of the Farm Security Administration during the Great Depression. Often these photographs have been exposed from front and center, in full, dramatic light, as if the photographer has been offered the best seat in the house and is up on its front edge, breathlessly waiting for the actors to walk on from the wings. Bruhn's photographs belong, in part, to this tradition and share in the same insight (*insight* being a particularly appropriate word to describe these images). And, it seems to me, some of my response to

Roger's pictures shares in the anticipation of the arrival of the characters and the dimming of the house lights on the various stages of human existence. And after I have spent some time with each of these images I can feel a standing applause from somewhere deep inside me, and I would hope that the sound of those hands clapping might carry off into the wings beyond the margins of the picture, where stand the shy ghosts, pleased by the recognition, waiting to step onstage for their encore in time.

For it seems to me that an important part of the content of Roger's photographs is the people who are absent—absent in actuality but present by the feeling of their absence. There is not an exposure in this collection in which there is not an invisible palmprint on the doorjamb or the smell of pipesmoke adrift on the breeze. By leaving the people out of the picture, this photographer has left them in. In looking at any work of art, it is not to the fine high geometry of arches that most of us respond, but rather to the human sweat we know has wet the doorknob.

Such a sensitive presentation of architecture honors and in many instances reveres its subject while transcending the merely physical. It *understands* architecture and places it in its human context. Roger Bruhn calls this "photography of architecture" (thus drawing a subtle distinction between it and the cooler, more calculated "architectural photography"), and that is what his fine book, *Dreams in Dry Places,* collects and presents.

PREFACE

Roger Bruhn

About four o'clock on a hot, dry Nebraska afternoon we were talking to a Morrill County rancher about the location of a couple of stone buildings on his property. He drew us a map: through this gap in the fence, along this ridge, down the valley, skirt a small stand of willow. Another fence. Ford the creek here; it's rocky but shallow. Follow the creek for a couple of miles, but stick to high ground. Go slow and don't get high-centered. It'll take an hour or so. Then you'll see the old buildings, returning to the earth. Watch out for rattlesnakes—you got boots? Oh, and one more thing: if you're not out by eight o'clock, we're comin' in after you. No place to be after dark.

We didn't make it out by eight, and true to his word, we saw the headlights bouncing along, headed our way in the half-darkness. But we got what we went in for: photographs and drawings of the Waggy ranch (no. 3).

Most of the images in this book were not that hard to get (though some were even harder). Many of the buildings you'll see here sit right along the road (that's what roads are for: to take you to buildings) or on a city street, in plain sight, for anyone to see. But more than a few are like the Waggy ranch—hidden, inaccessible, forgotten. Dreams lived, and sometimes died, in these structures, and it is the dream as much as the building itself that I have tried to photograph.

I have photographed in black and white, not because I don't like color or can't work with it, but because black and white is the medium appropriate to my subject matter and my intentions. Color shows us what we already know: the passing, ephemeral, phenomenal scene. Black and white (and gray) is the palette of the Unconscious—the color, psychologists tell us, of dreams. Black and white emphasizes form, the archetype, the general, the eternal. It abstracts and informs us in a way quite different from color. Color seduces the sense of sight and detracts from meaning. Color is on the surface of things, and I want to get under the skin, down to the marrow.

This book began several years ago with a grant from the Nebraska Committee for the Humanities. Dave Murphy, John Carter, and I were to produce an exhibit on Nebraska architecture. Murphy, the preservation architect, would locate and make drawings of the buildings; Carter, the photographic historian and folklorist, would hold

the ruler and philosophize about them; and I would photograph them. We would all argue late into the night about what we were doing and why we were doing it and what it all meant.

The exhibit was completed, it opened, it toured. As of this writing, it is still touring. But, as anyone who has seen the exhibit will know, this book, though it retains the title, is very different from the exhibit. In the first place, not all the images in the exhibit are in this book, and vice versa. The captions and quotations that accompanied the exhibit are absent here. The exhibit attempted, through photographs and words, to *explain* something about architecture. In this book, with images alone, I hope to make you *feel* something about striving, about aspirations—about dreams. I don't want to teach; I'm not qualified for that. I want to tell a story, a story in pictures, but a story nonetheless. Buildings are the nominal subjects, but that is the way with photography: only the material world will appear on film. *You* have to supply the dream.

ACKNOWLEDGMENTS

Many people deserve credit and thanks for the existence of this book. Keith Sawyers, professor of architecture at the University of Nebraska, whom I first met when I was an undergraduate philosophy student, communicated to me an enthusiasm for the nuances of architecture which has endured to this day. David Murphy, Deputy State Historic Preservation Officer at the Nebraska State Historical Society, provided me with the opportunity to work on the original exhibit from which many of the photographs in this book were drawn and shared his research and his insights into architecture. Our many hours of discussion about architecture and photography immensely increased my appreciation of and sensitivity to the issues involved in the merging of these two arts. John Carter, Curator of Photographs at the Nebraska State Historical Society, also joined in many of the discussions relating to the topic of this book. His ideas, suggestions, and especially his enthusiasm continue to be valued. I am also deeply indebted to Bill Ganzel, himself an excellent photographer, for wide-ranging discussions about the nature of photography as a medium and for his invaluable help in establishing the sequence of the photographs in this book. Ted Kooser deserves special thanks for writing the Foreword. After many years of admiring Ted's work, it is a great satisfaction to have his matchless writing grace this book. Ed Zimmer, architectural historian and preservation planner for the city of Lincoln, spent many hours researching and writing the notes to the photographs. And finally, and certainly not least of all, I would like to thank my wife, Lynne Ireland, for her unfailing support, certain understanding, and constructive criticism of my work.

In the dry places, men begin to dream.

Where the rivers run sand, there is

something in man that begins to flow.

—Wright Morris,

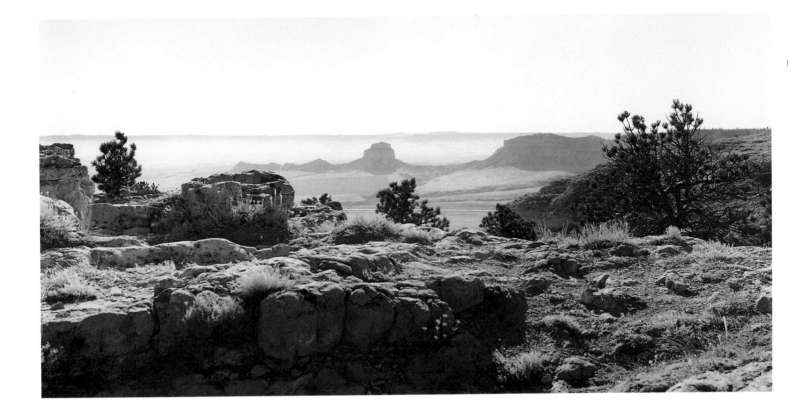

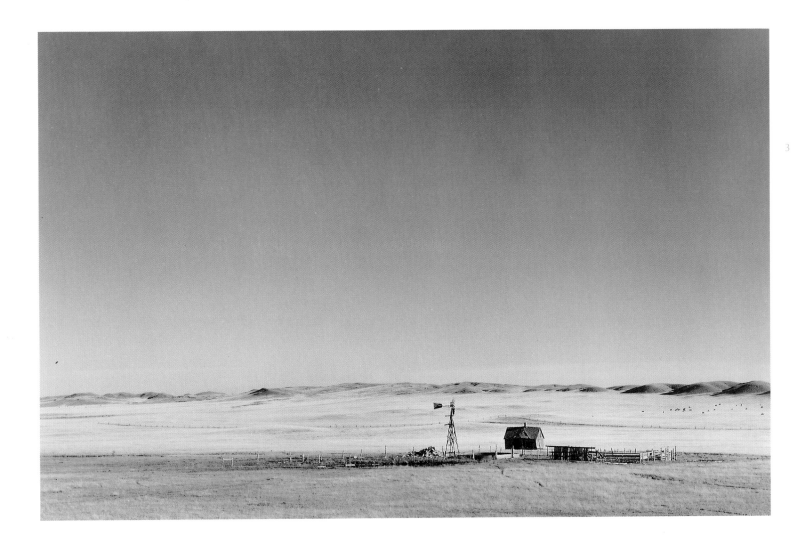

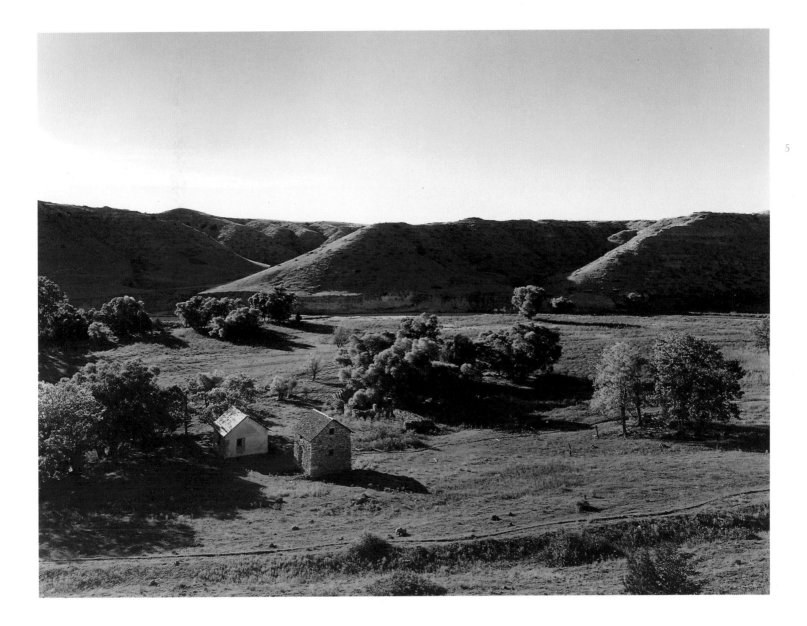

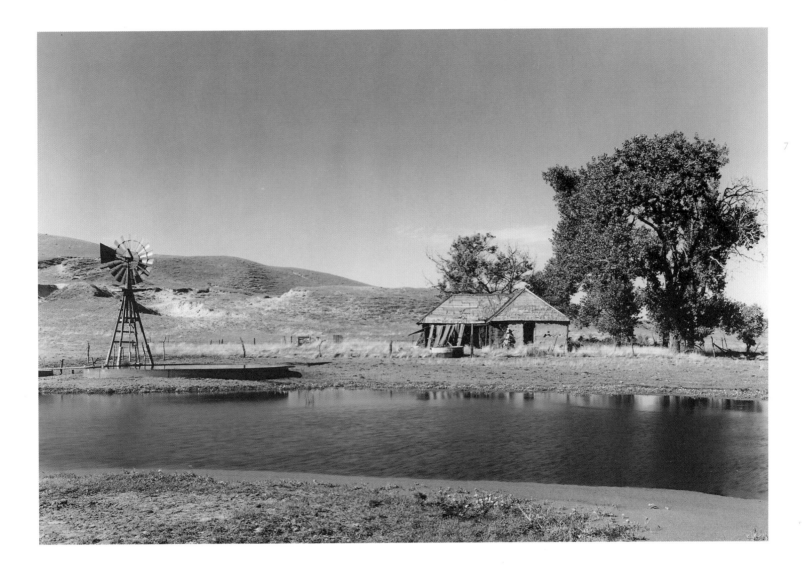

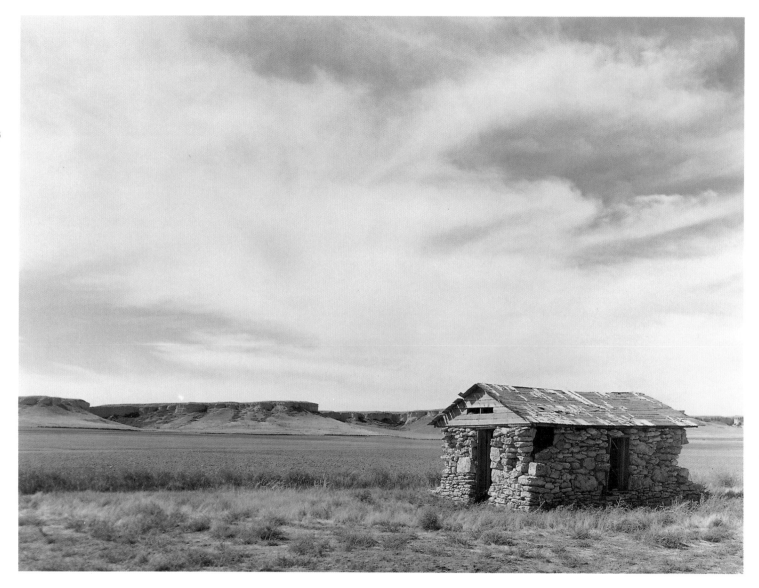

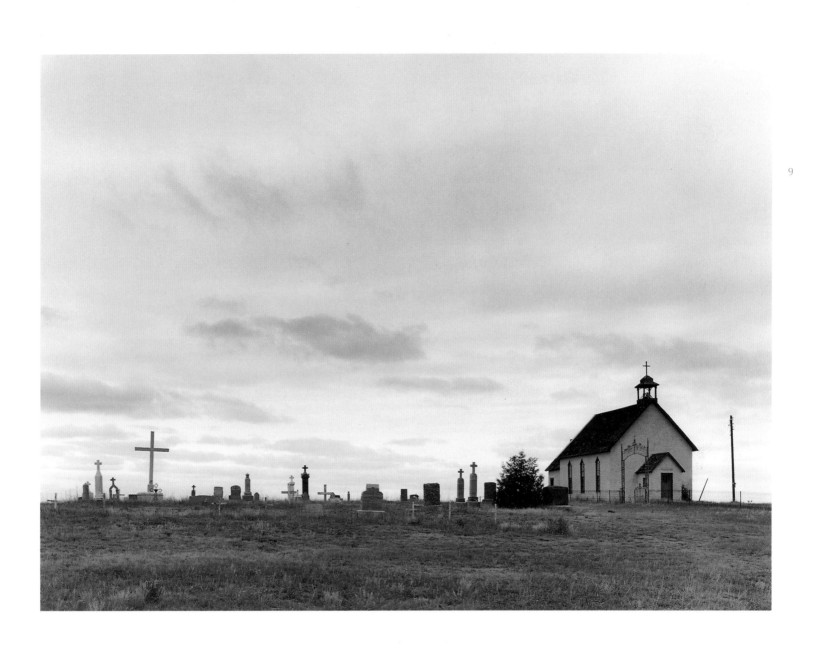

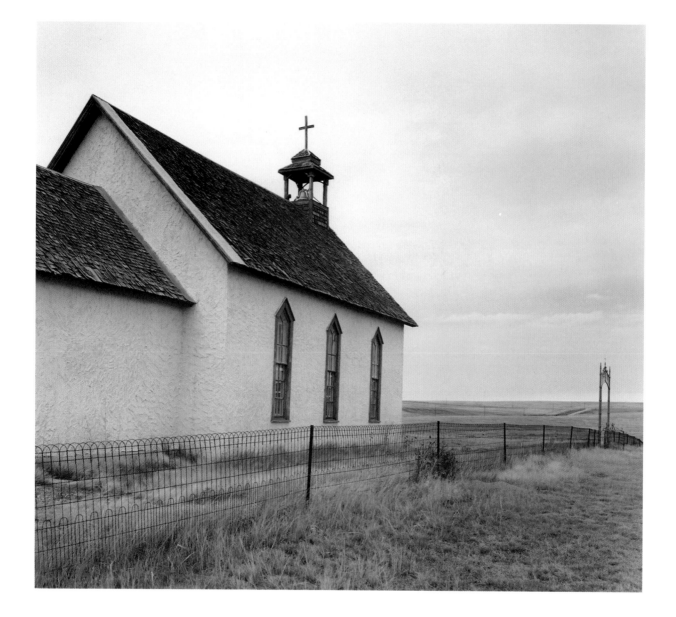

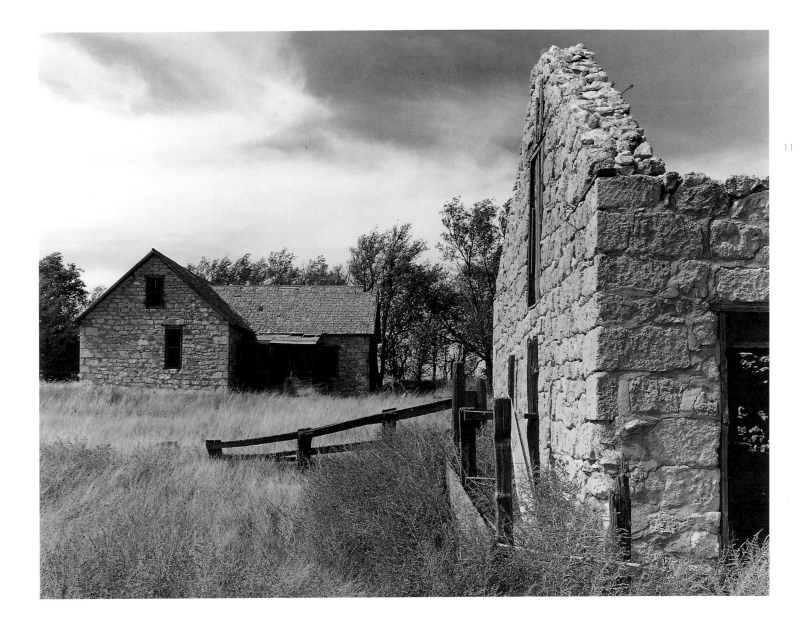

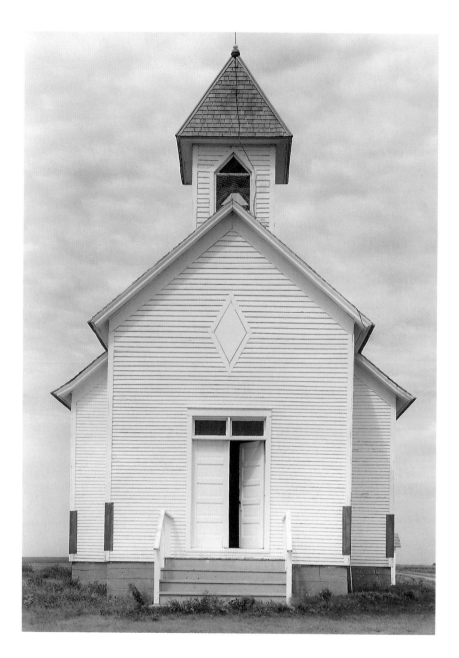

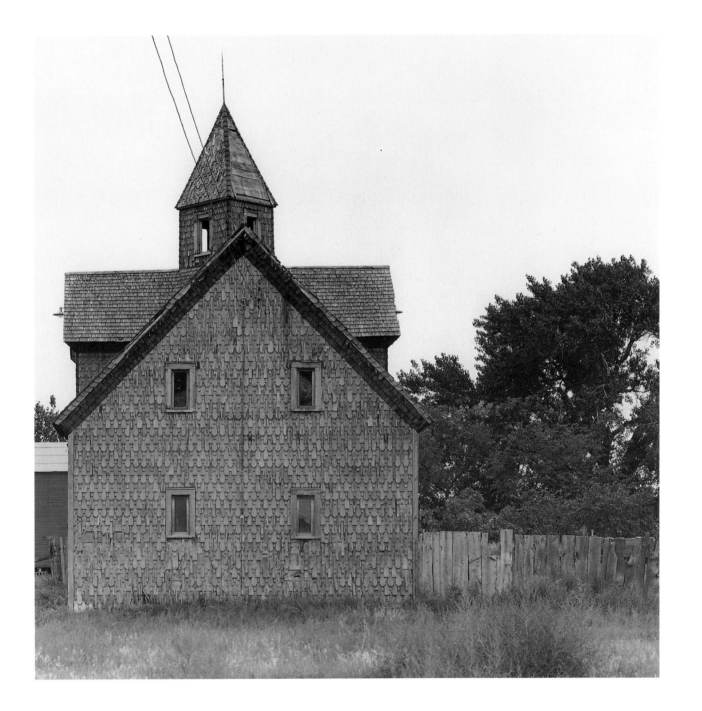

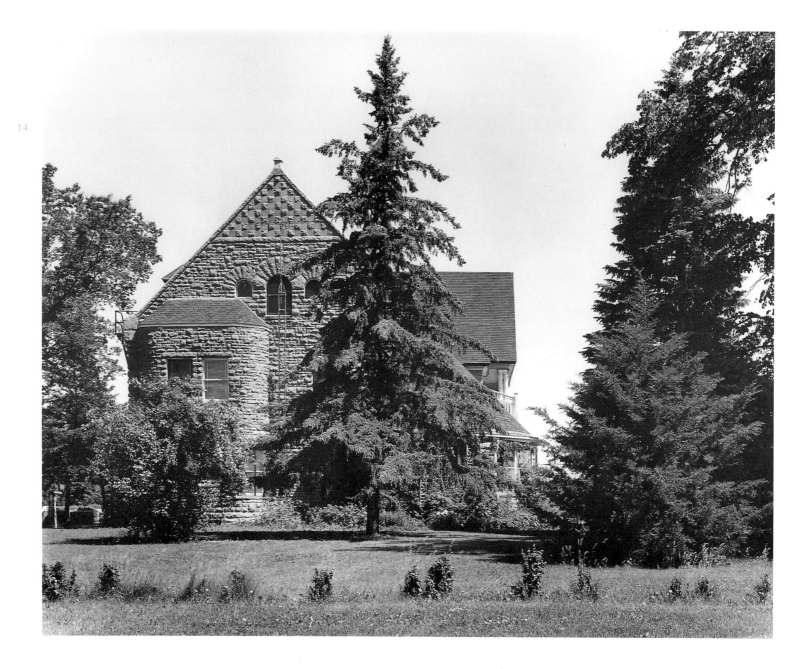

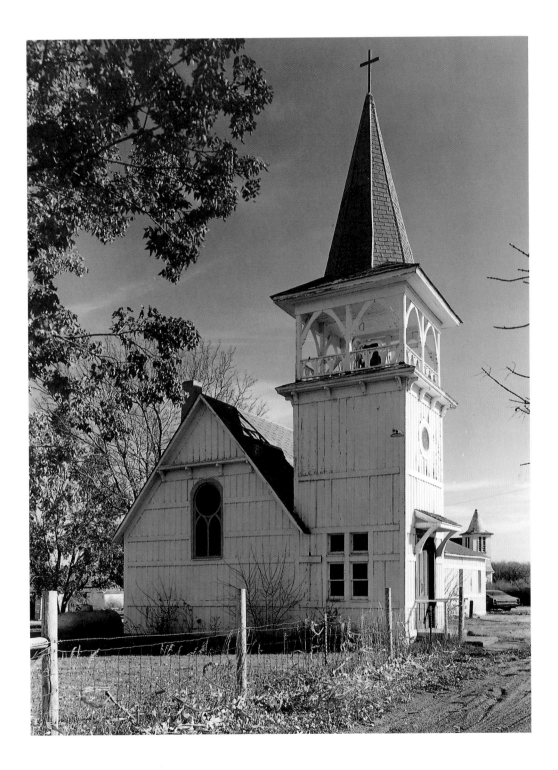

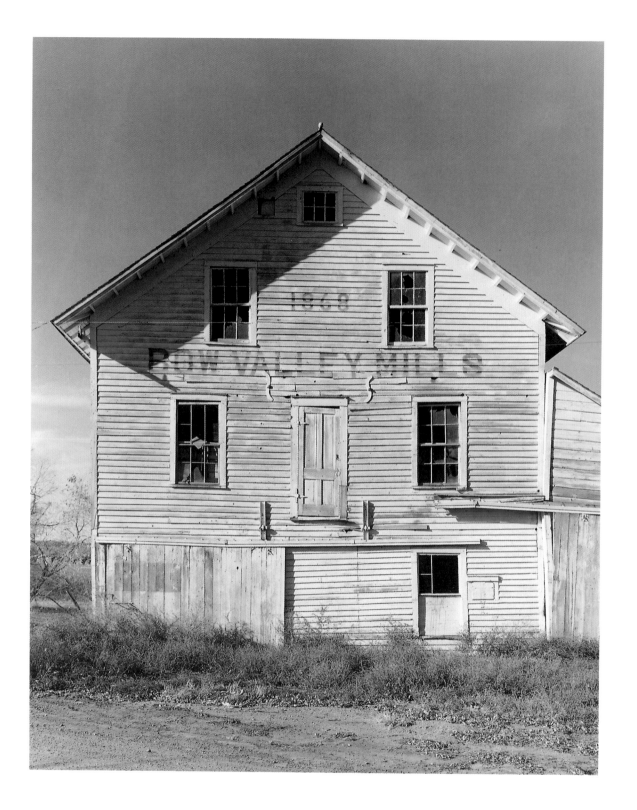

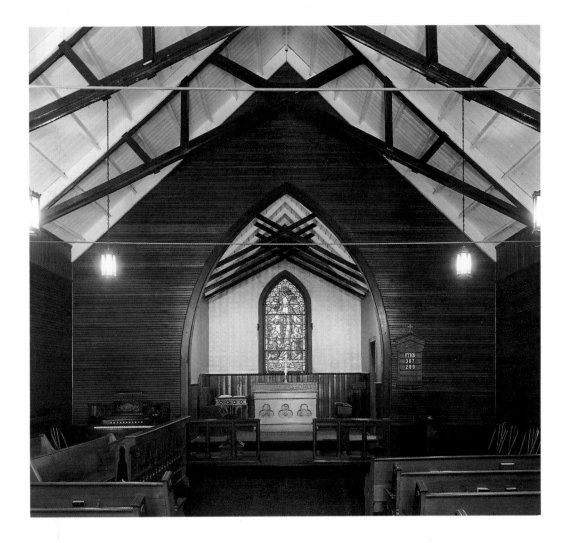

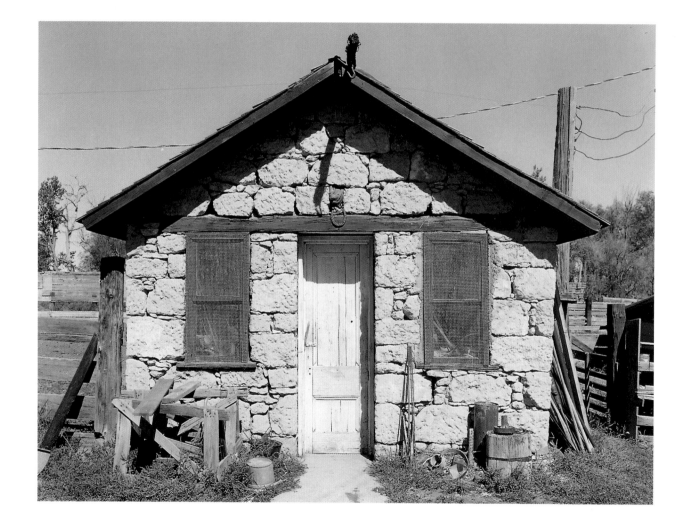

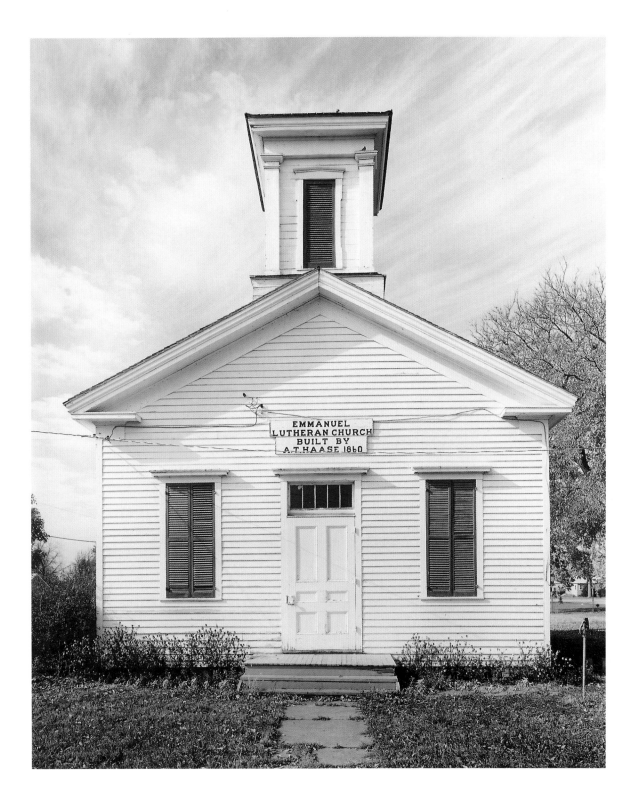

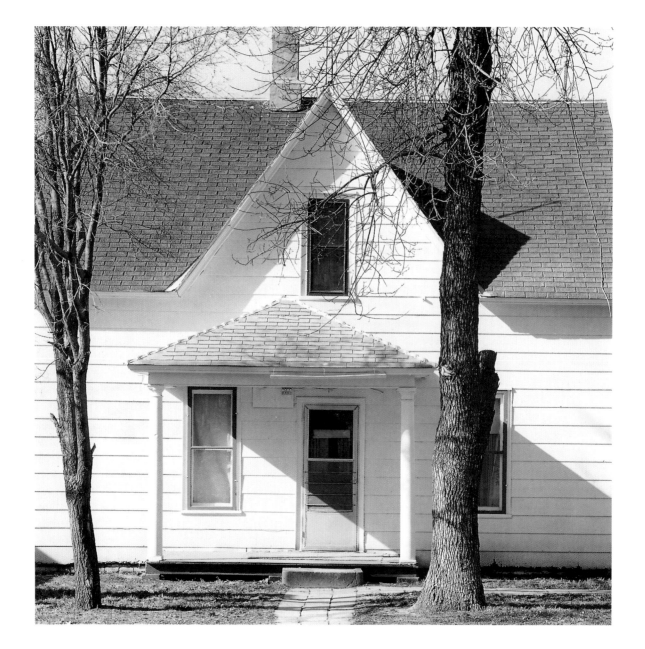

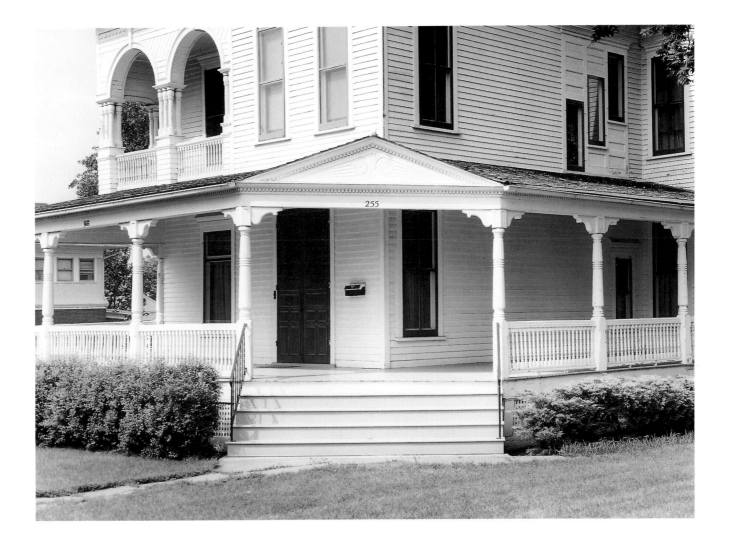

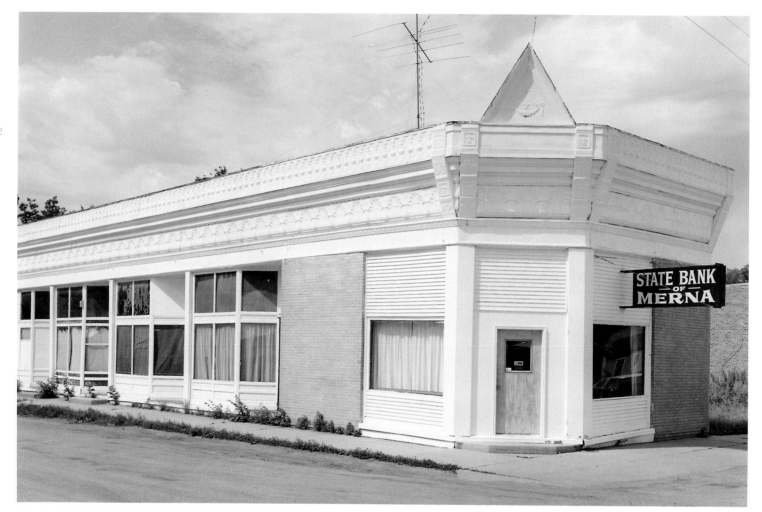

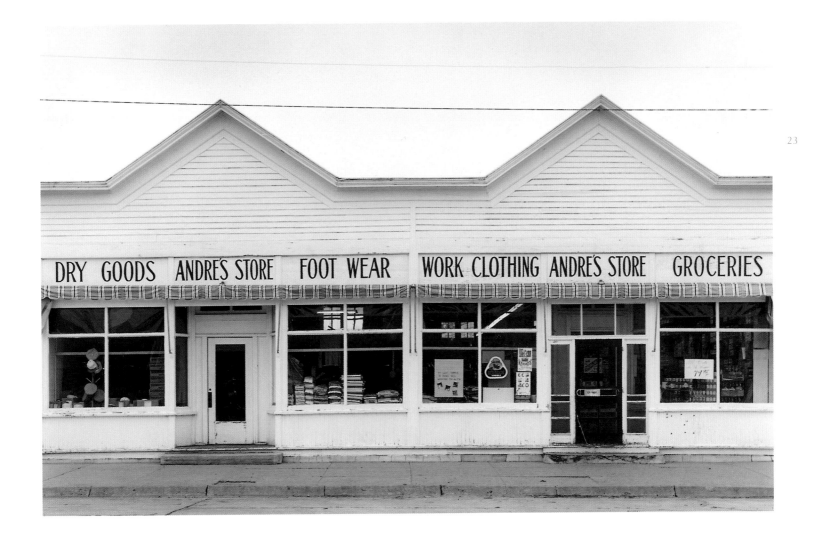

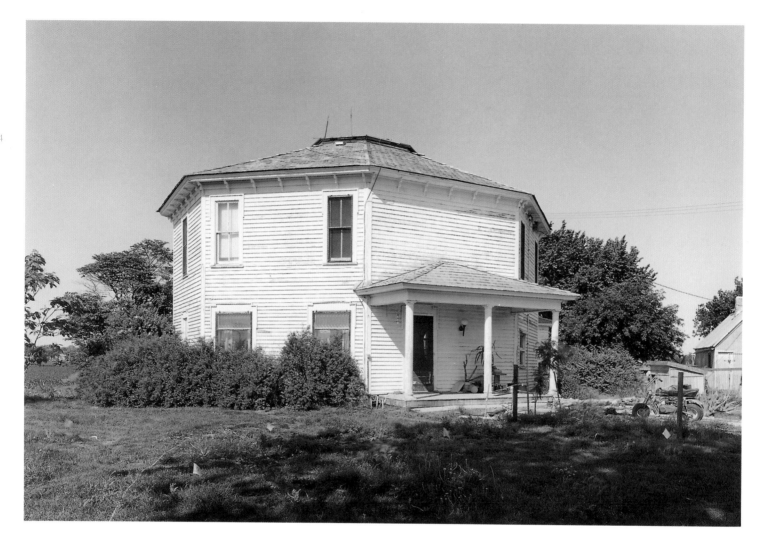

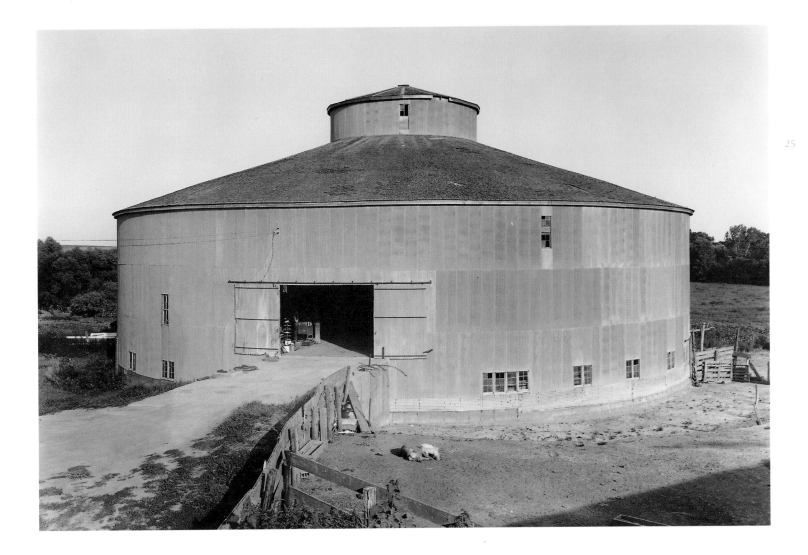

26

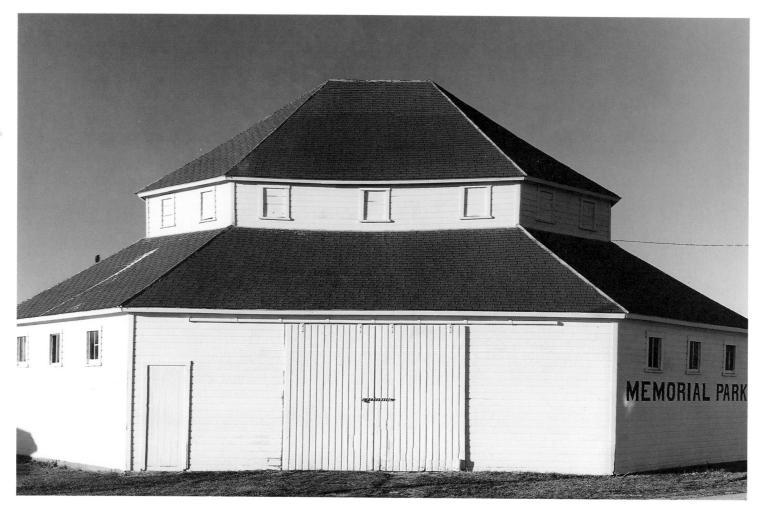

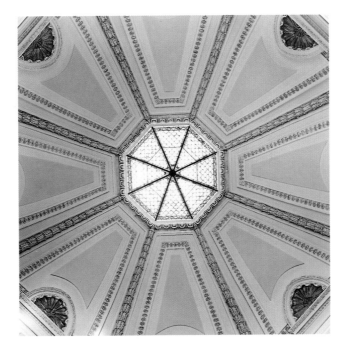

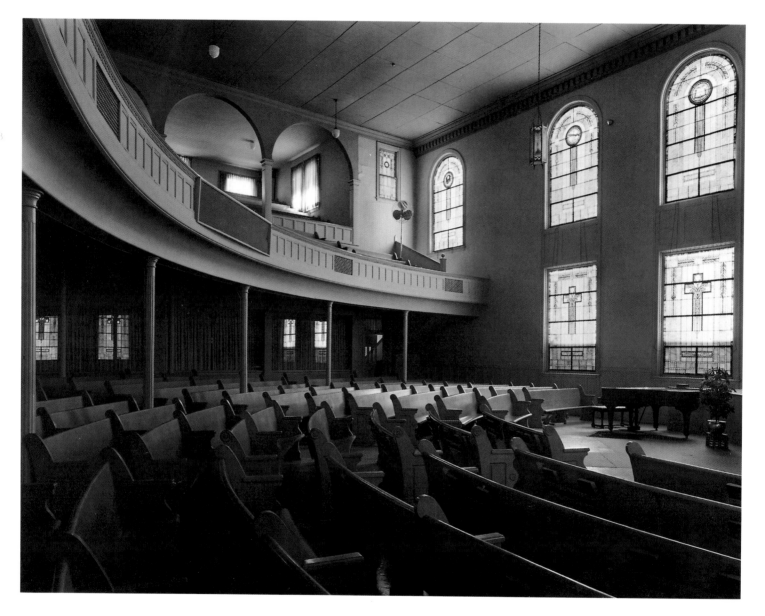

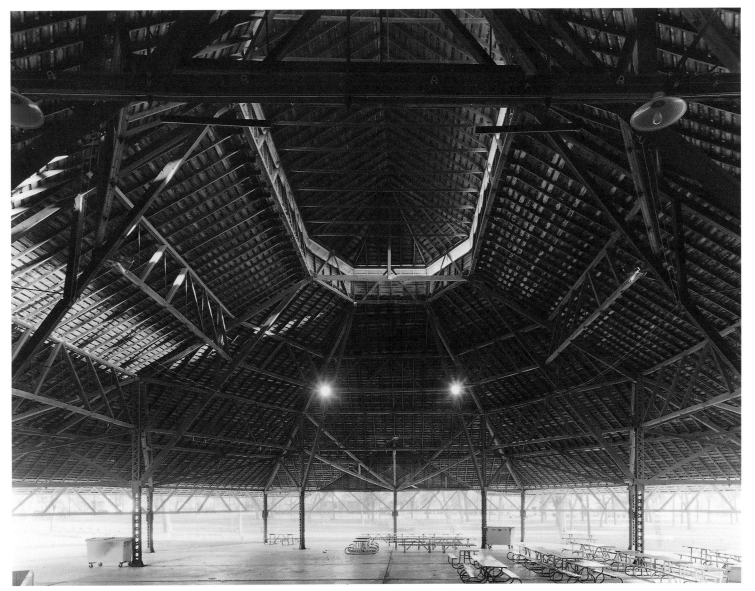

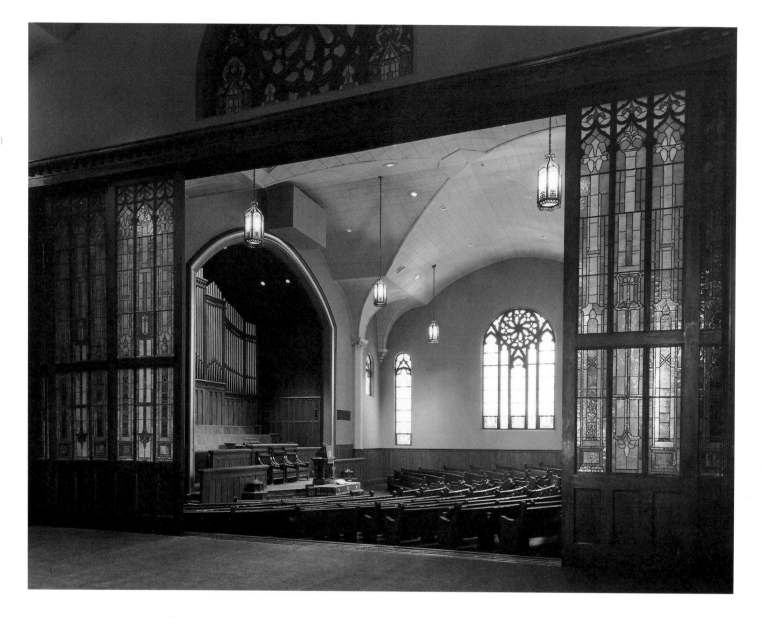

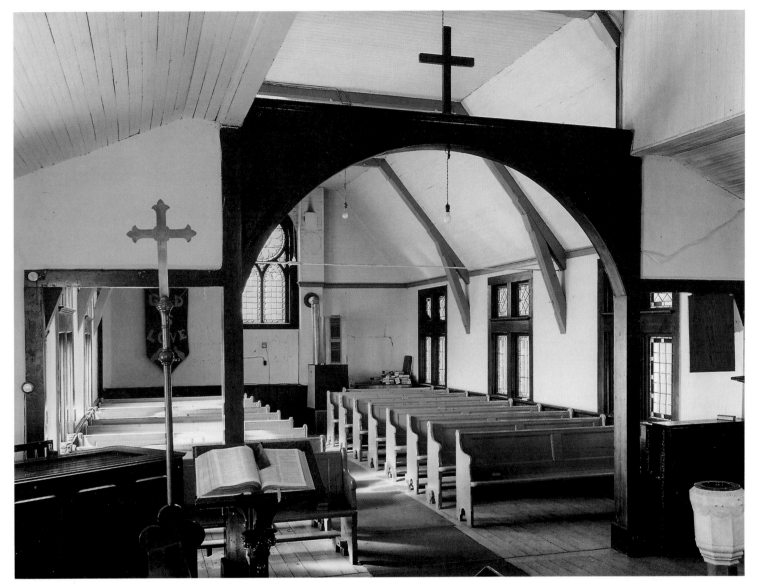

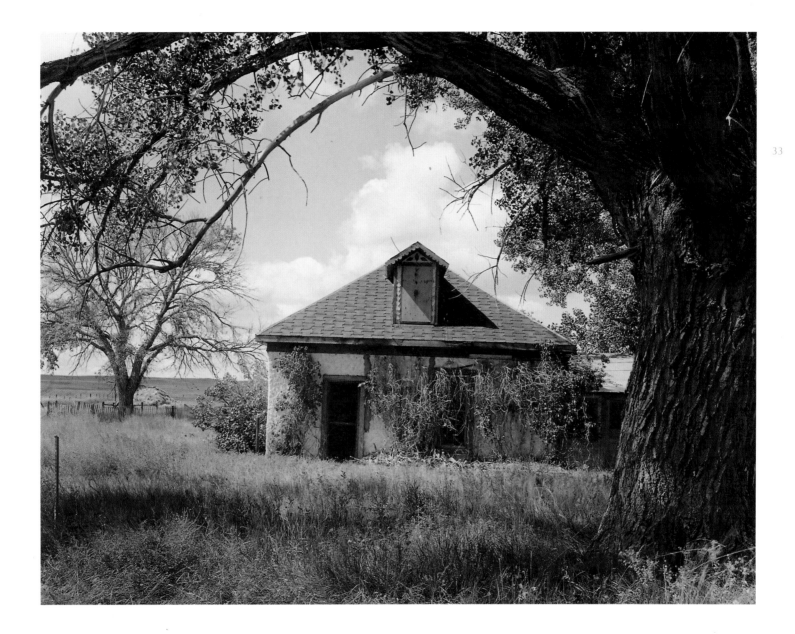

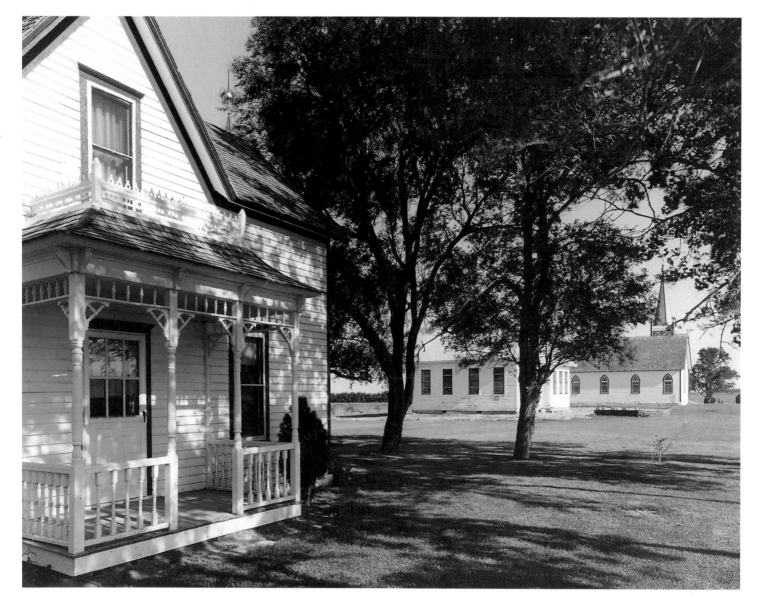

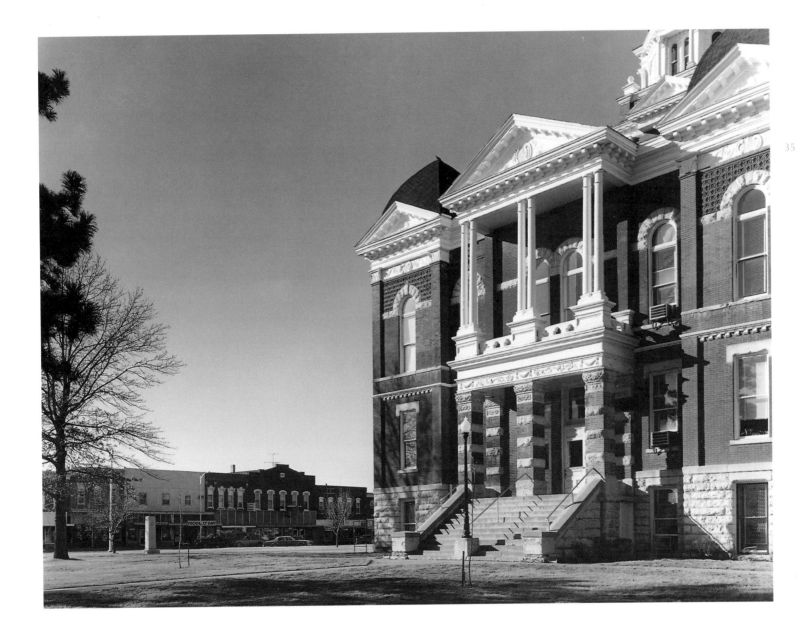

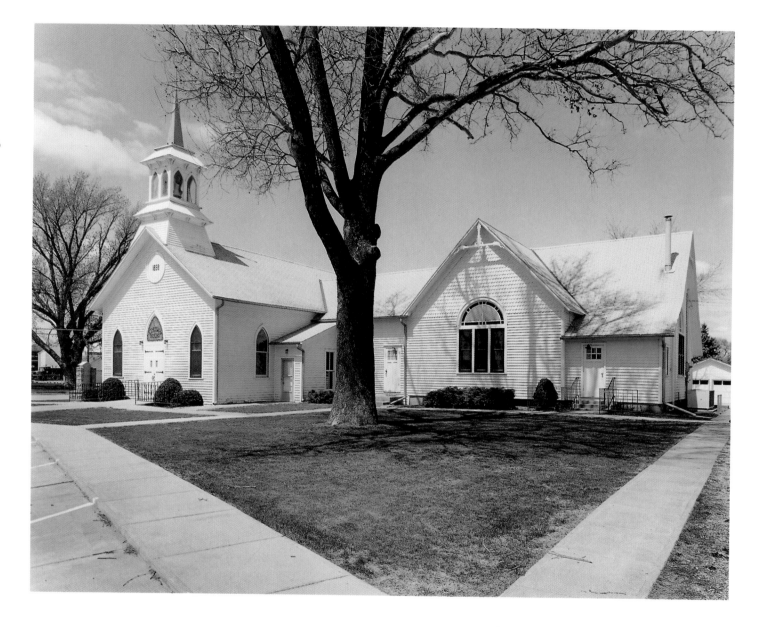

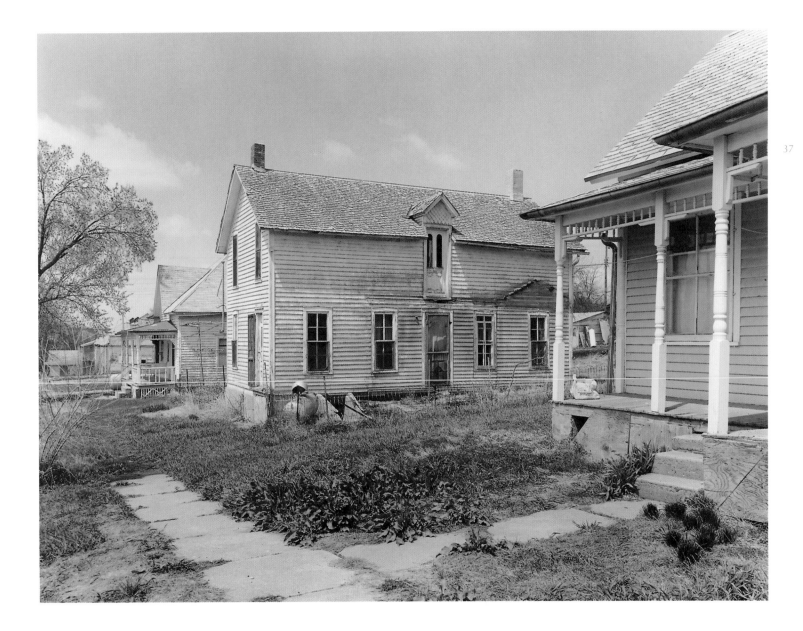

37

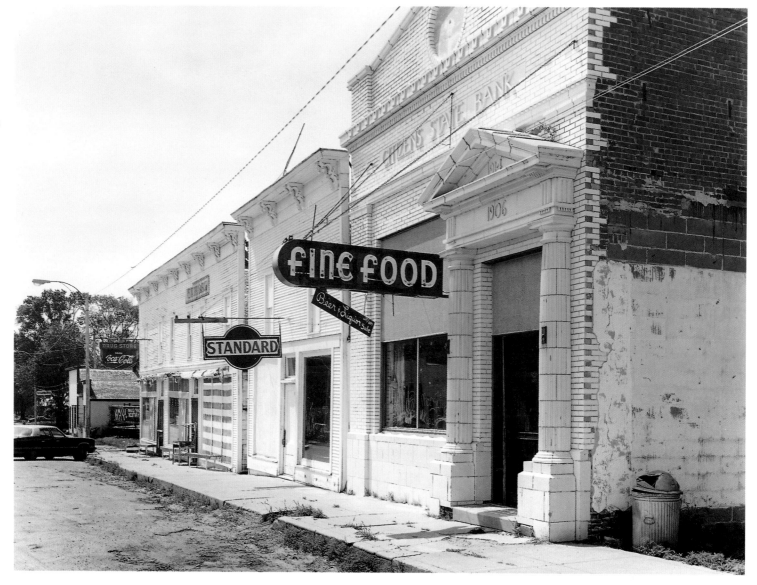

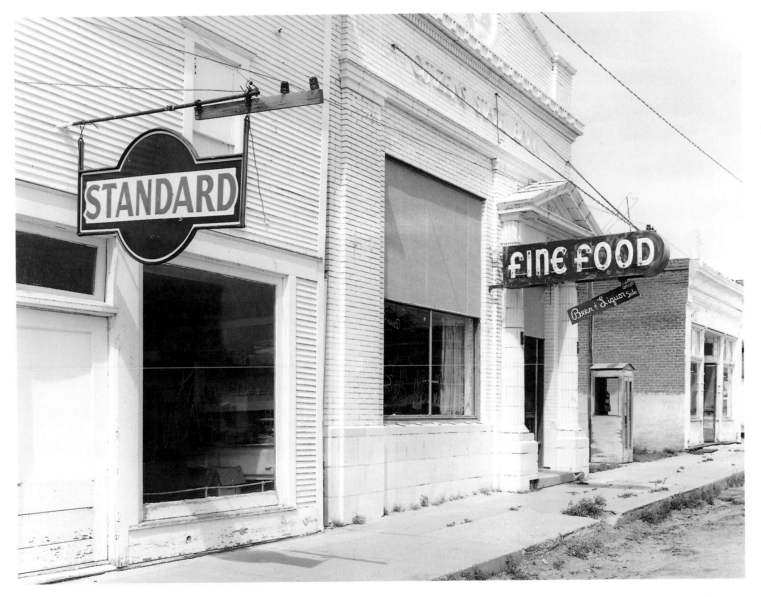

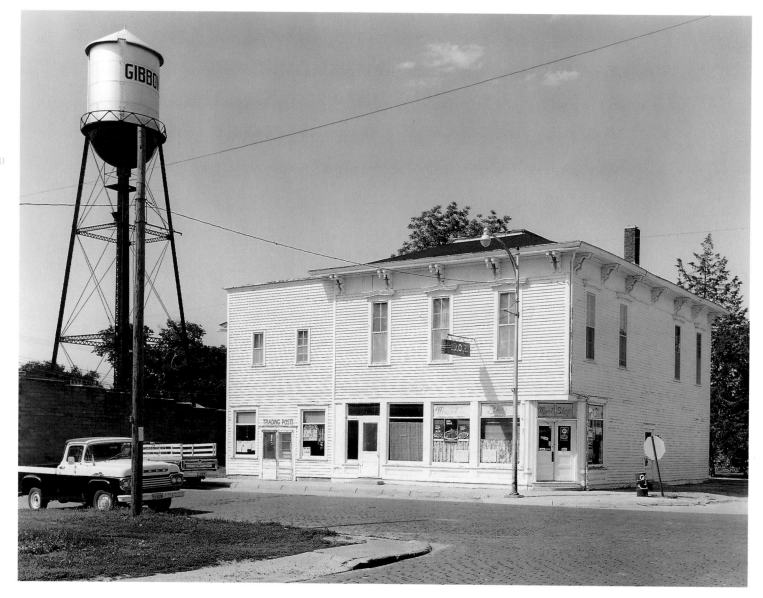

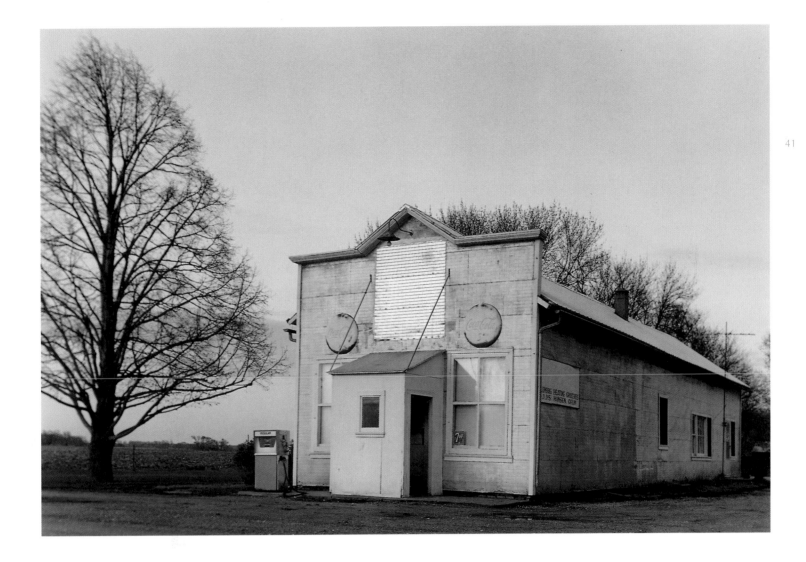

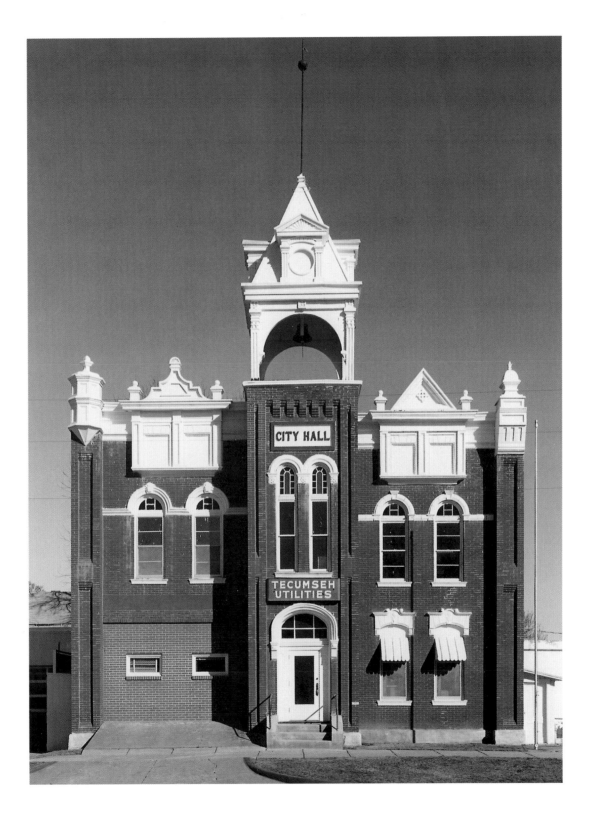

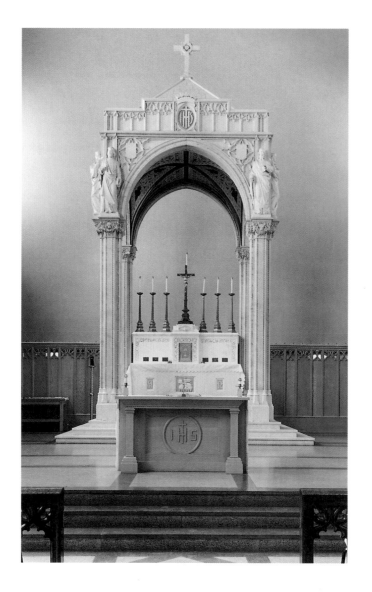

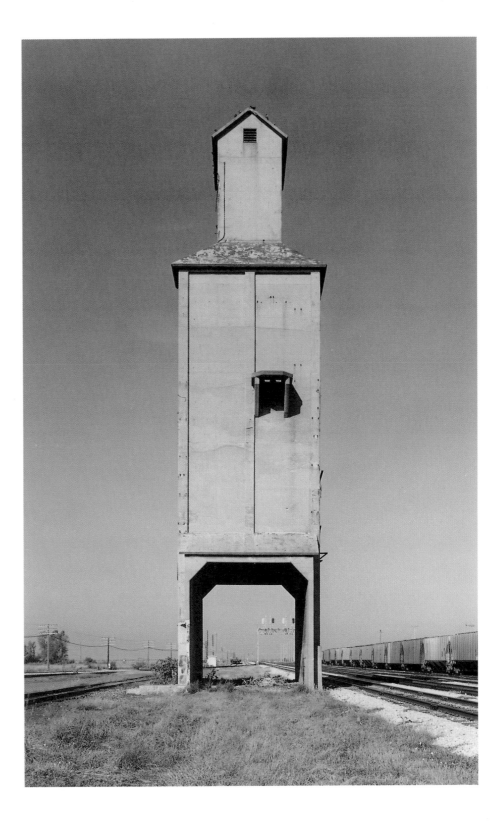

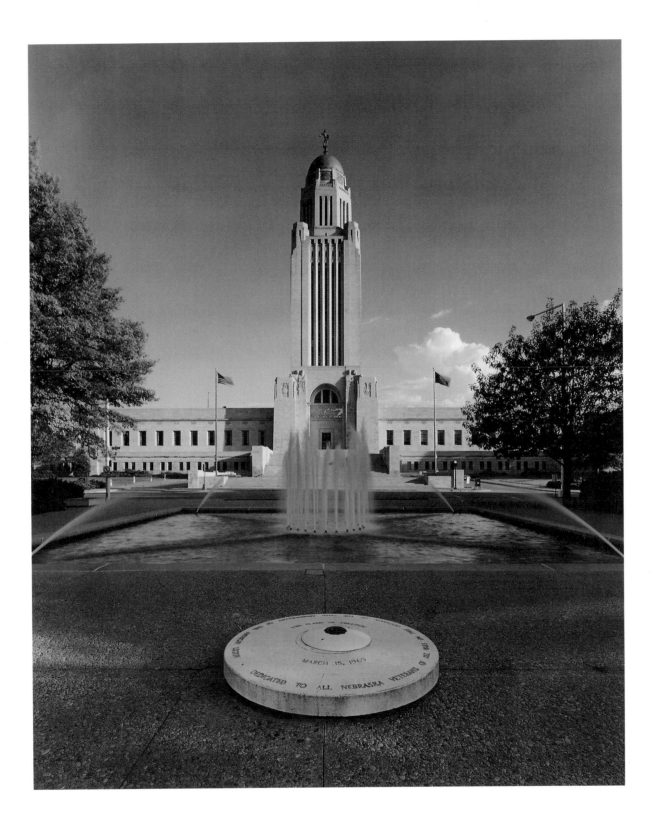

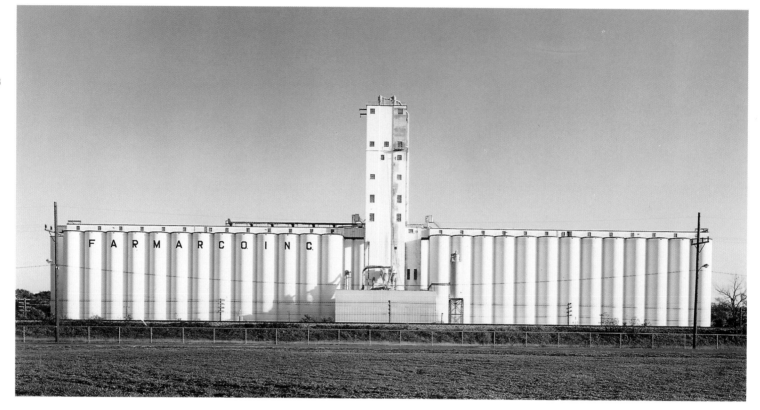

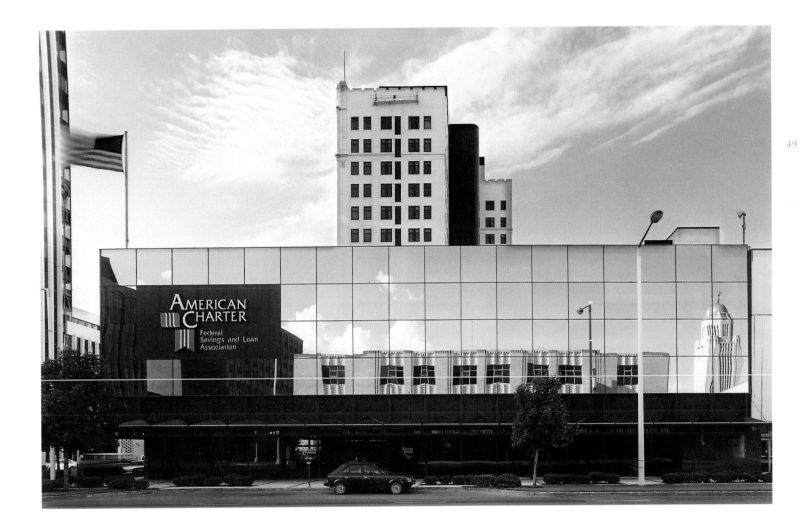

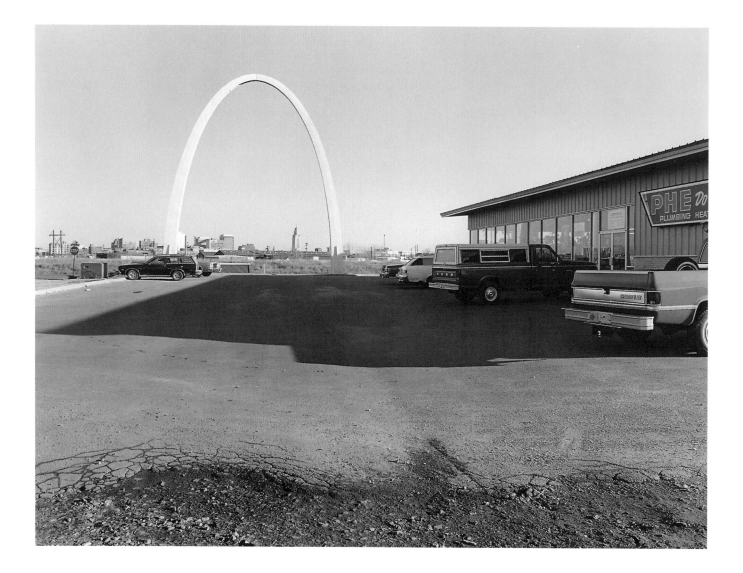

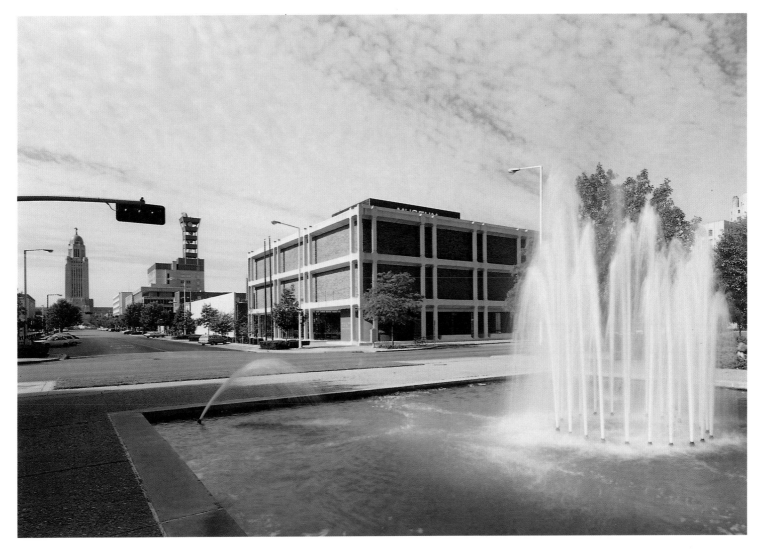

51

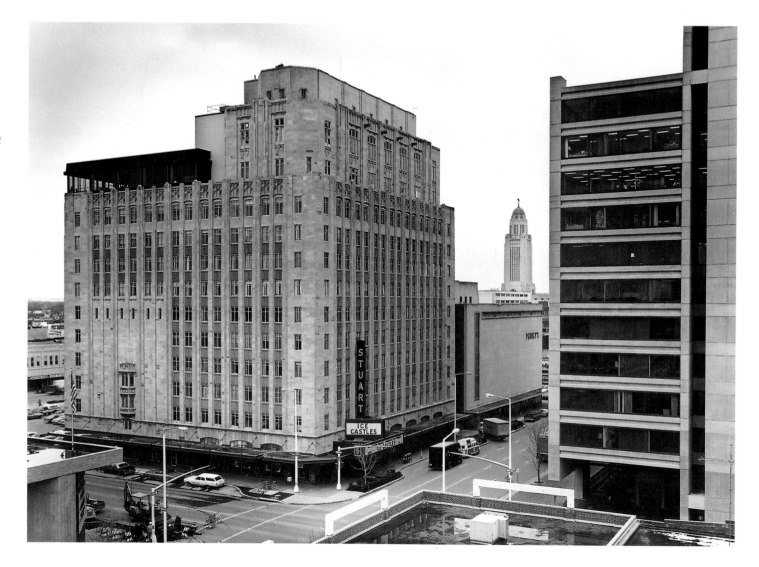

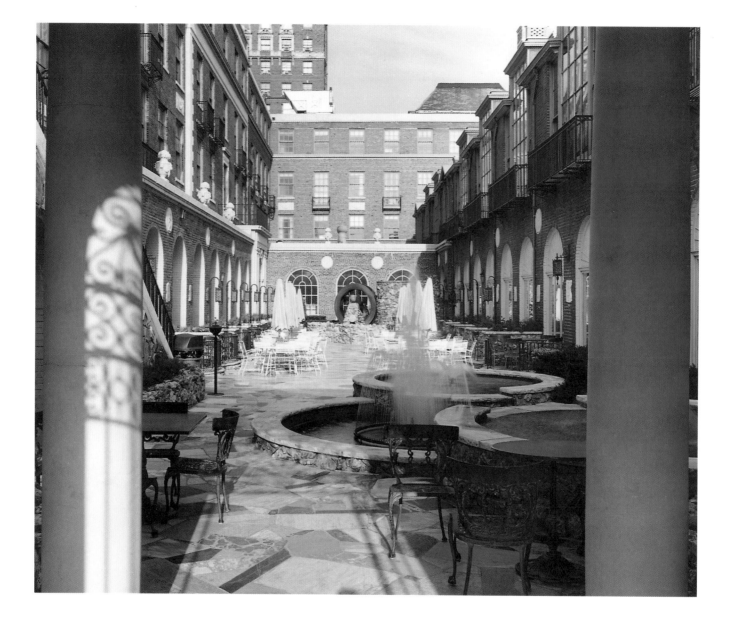

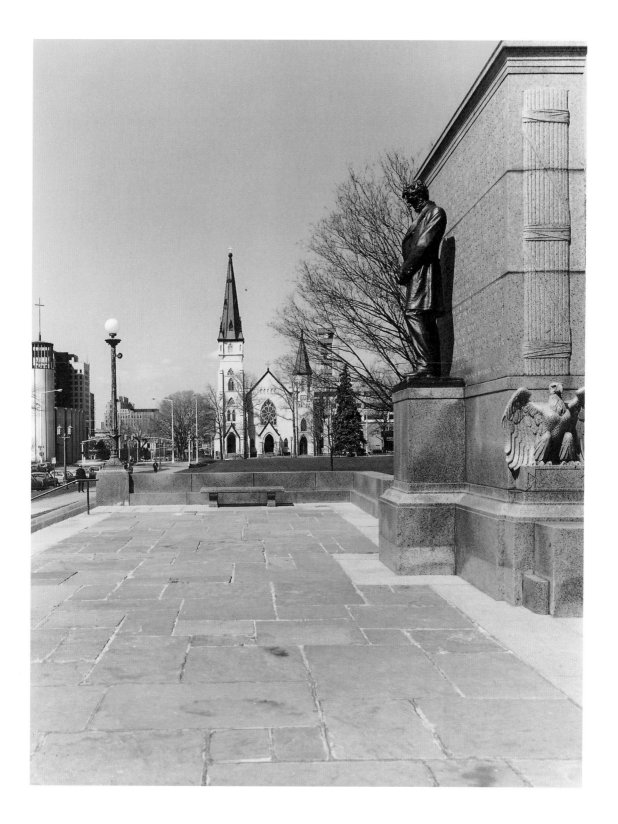

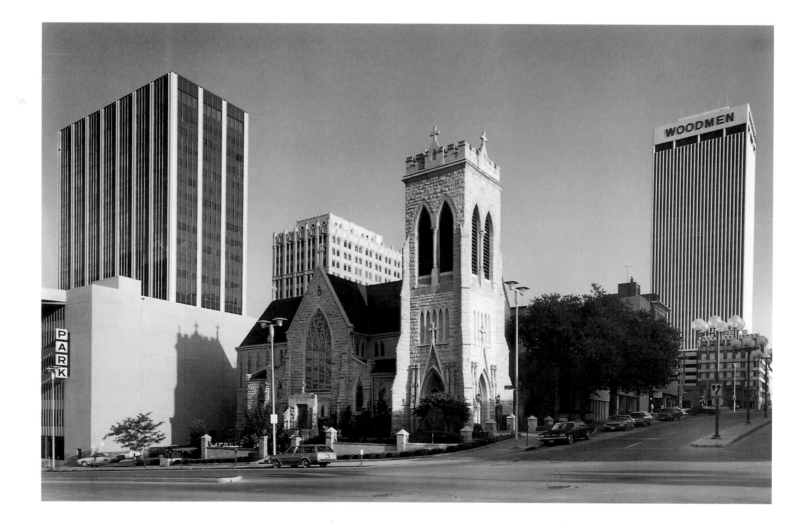

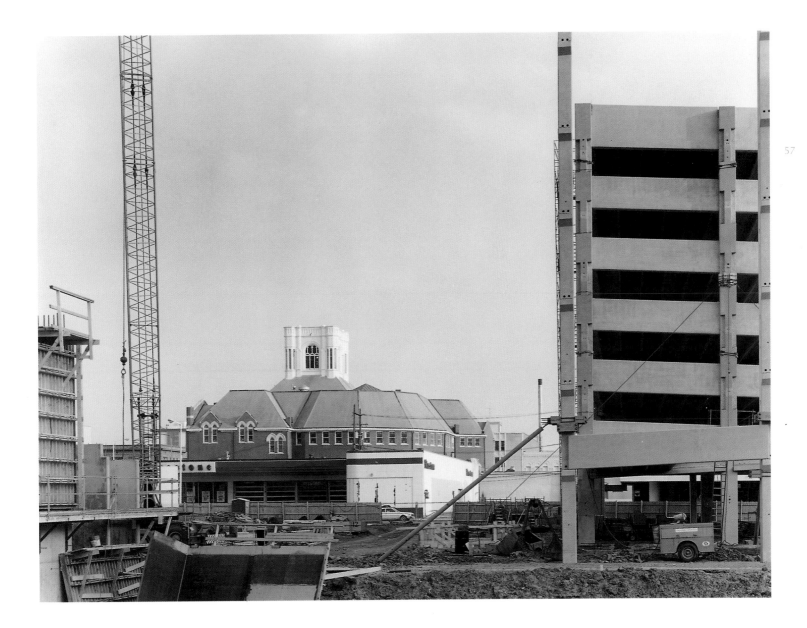

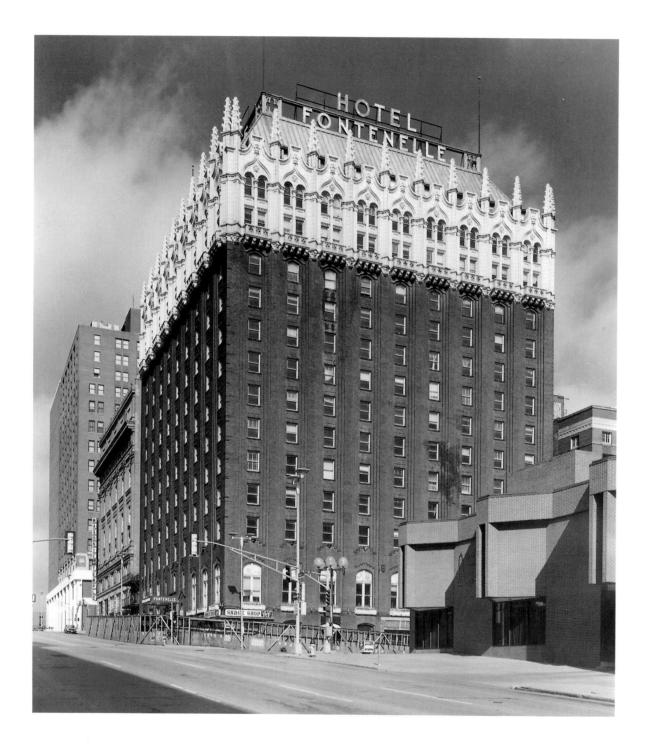

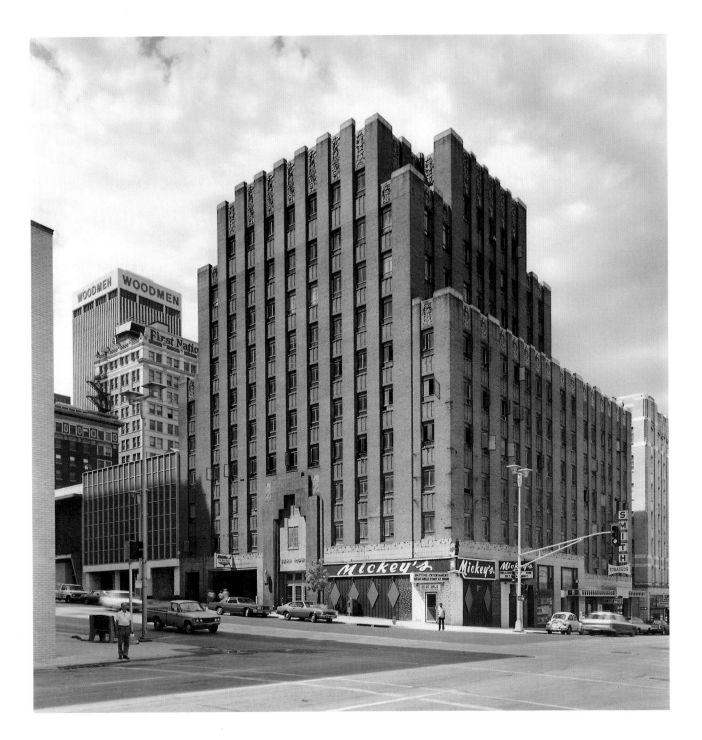

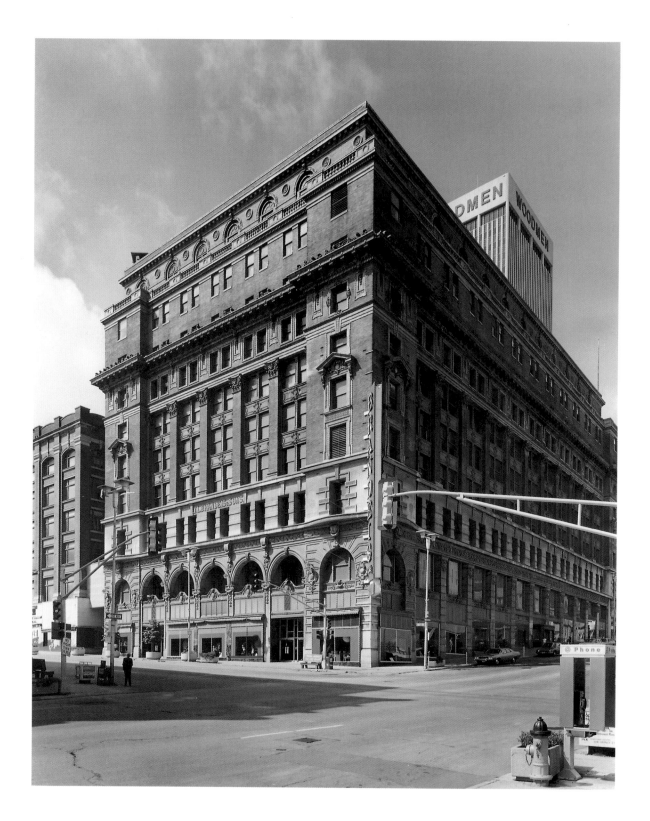

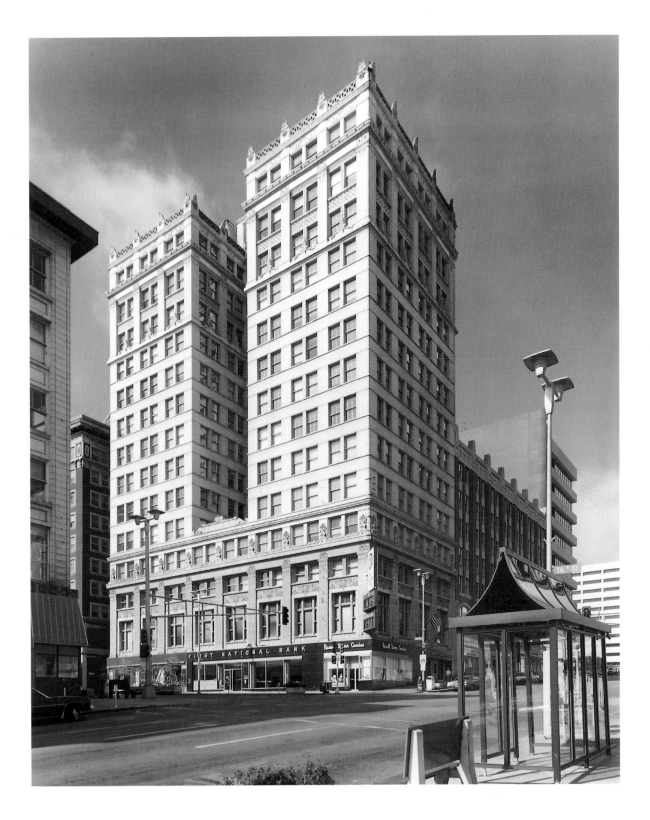

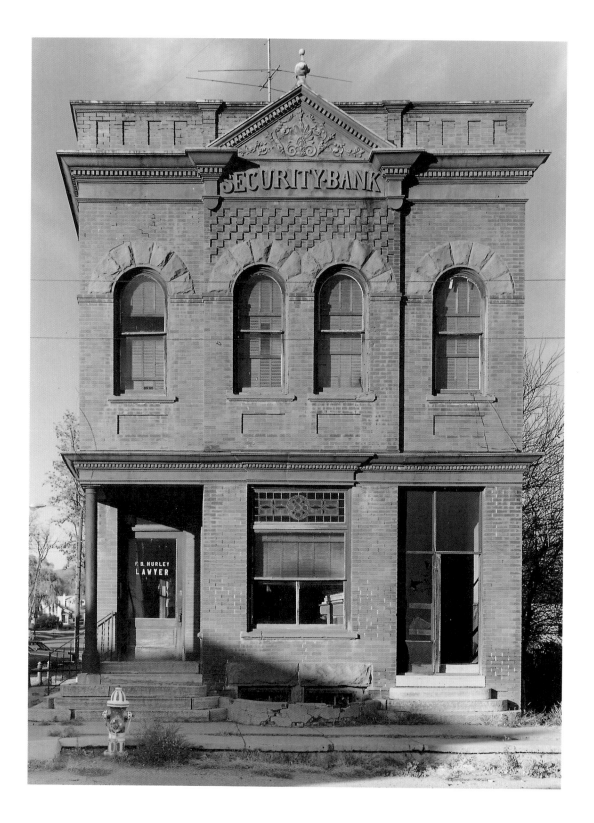

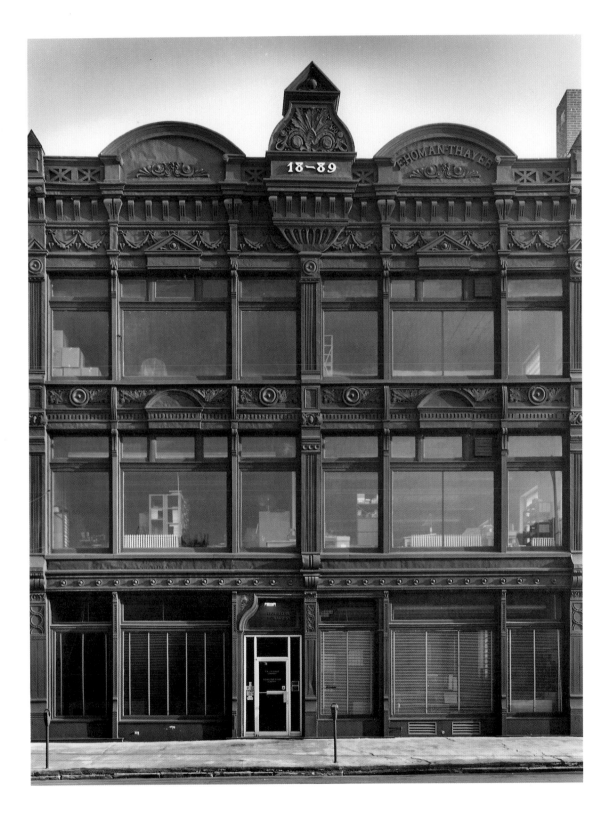

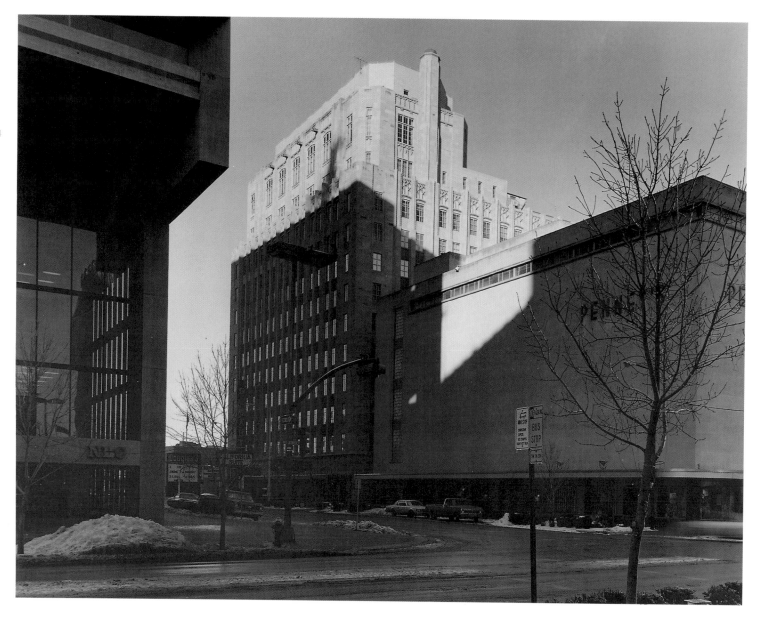

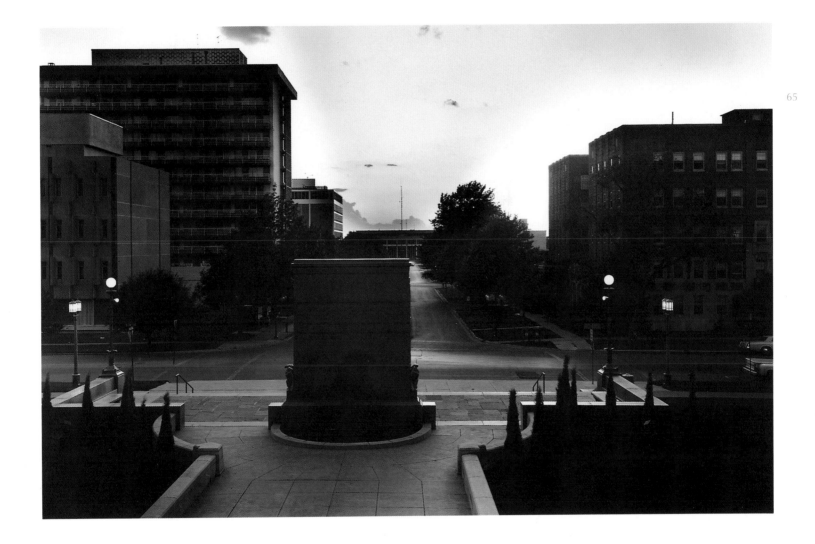

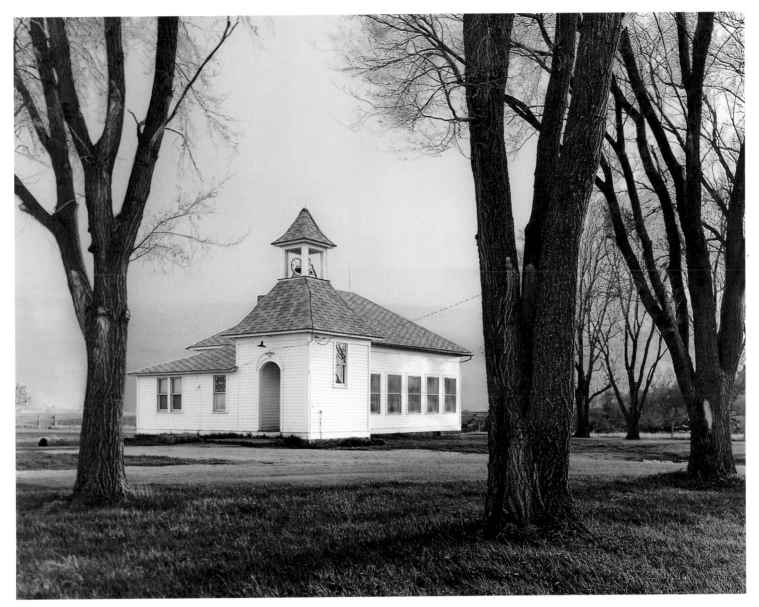

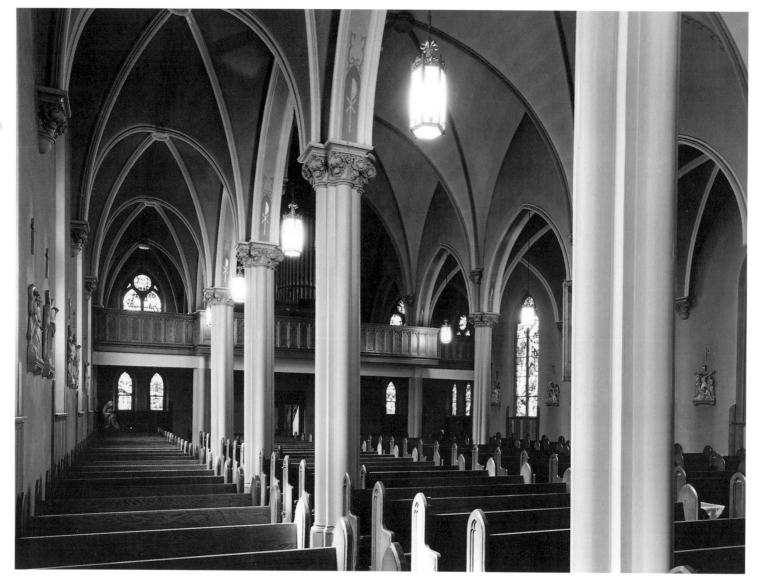

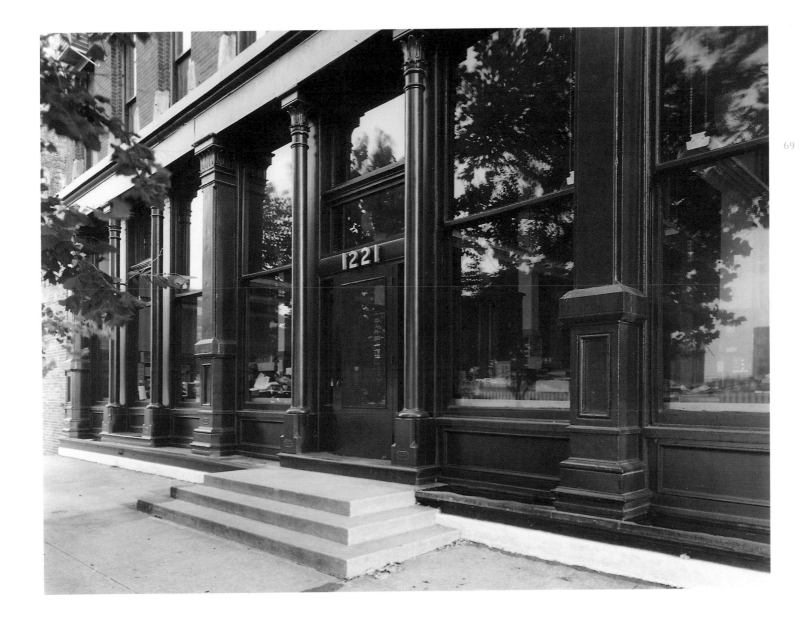

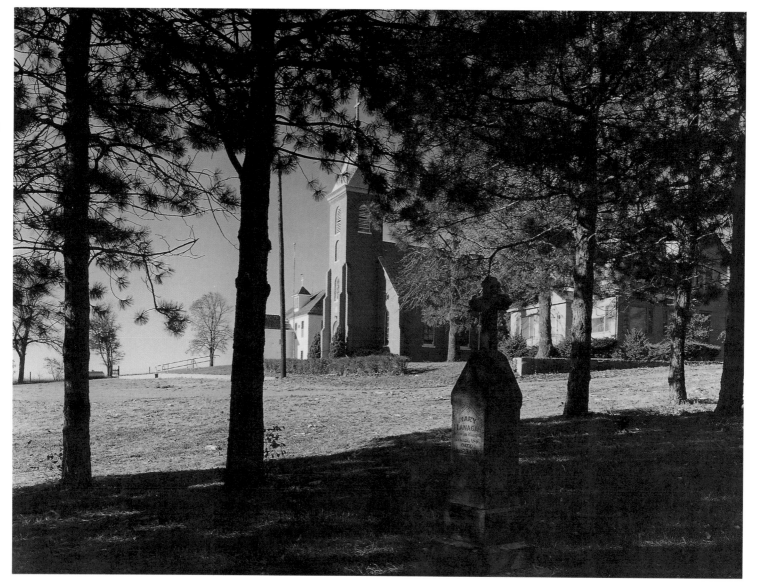

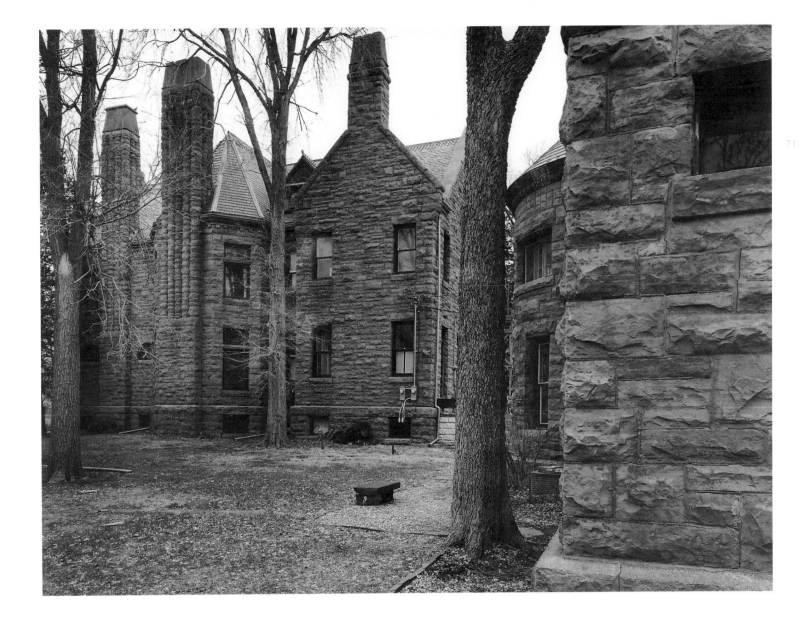

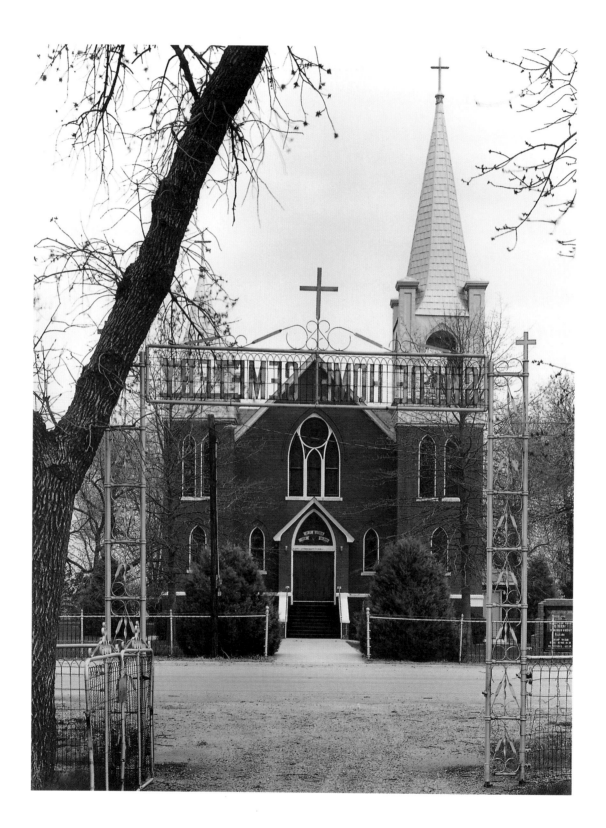

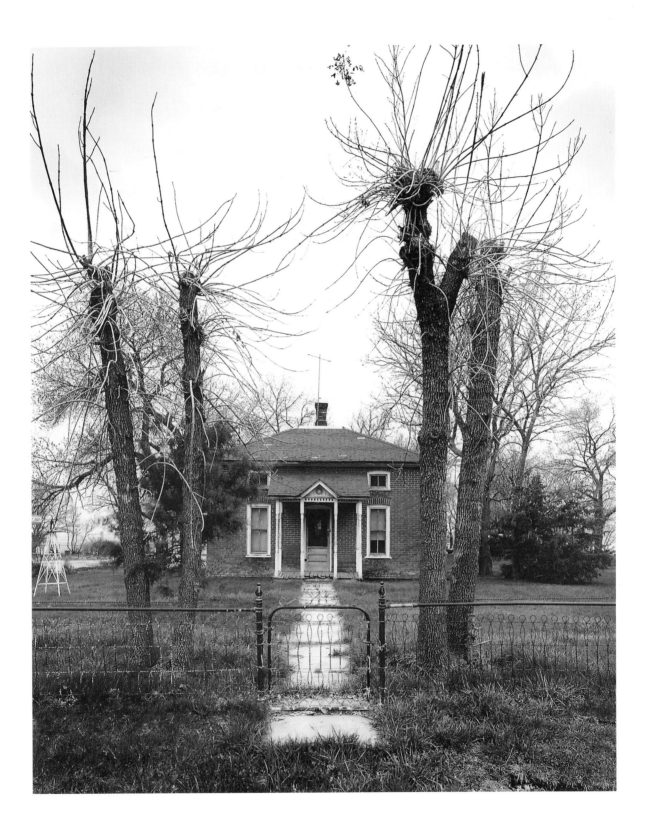

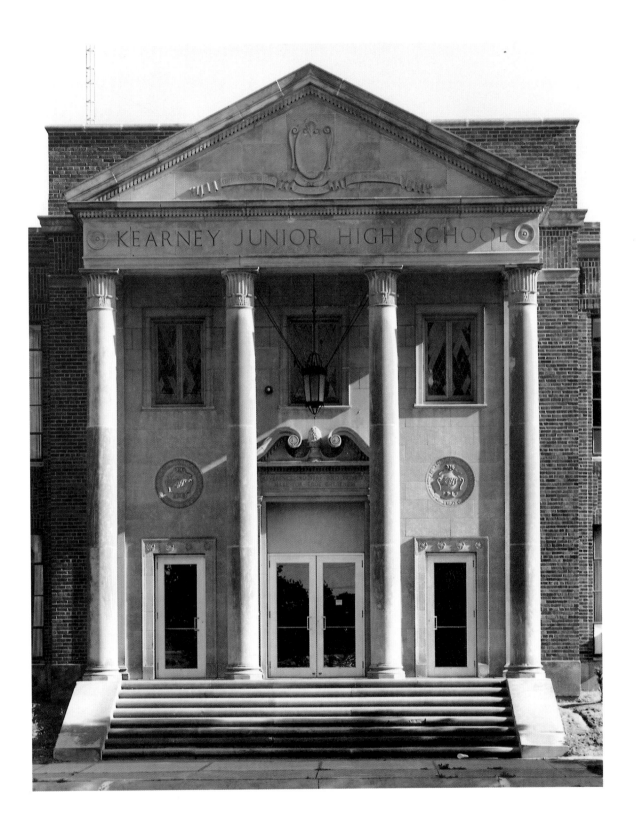

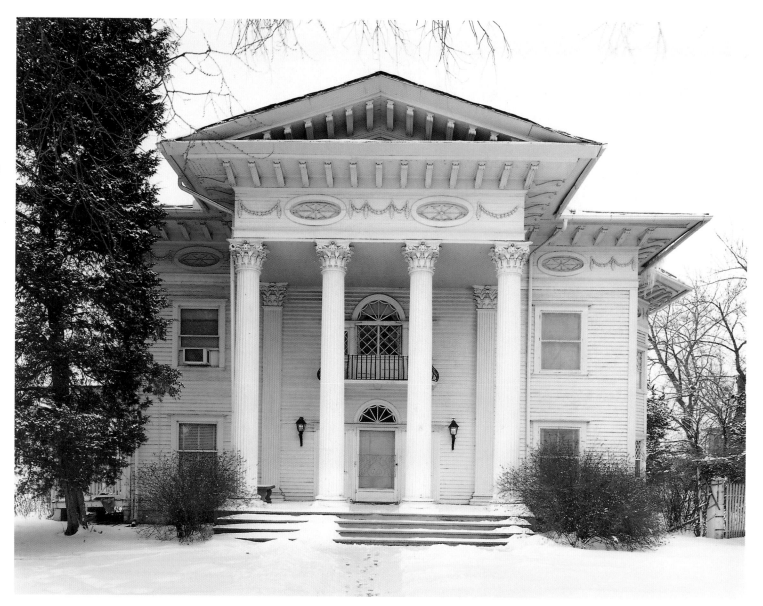

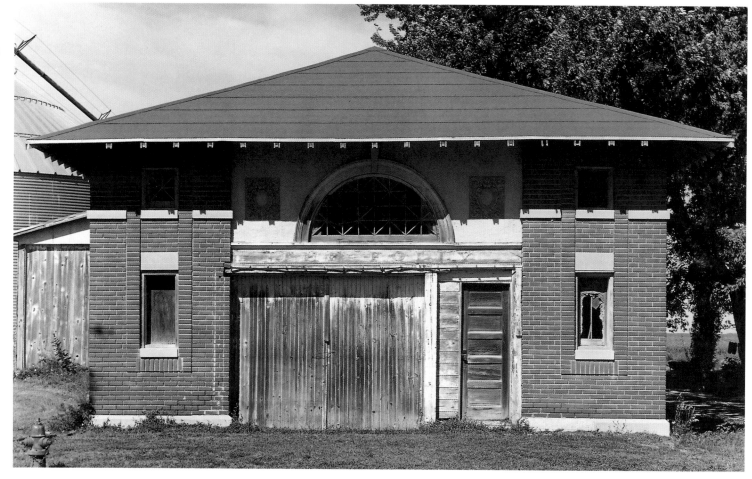

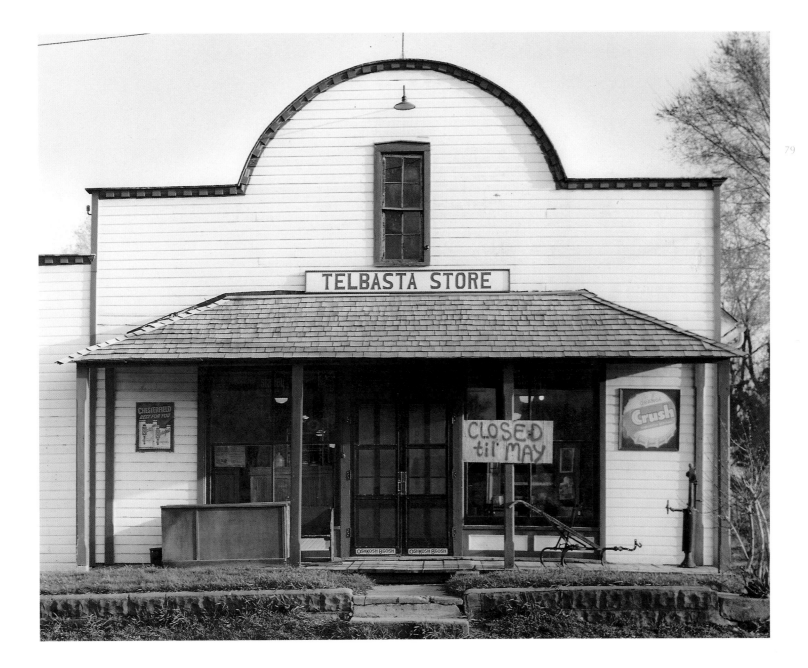

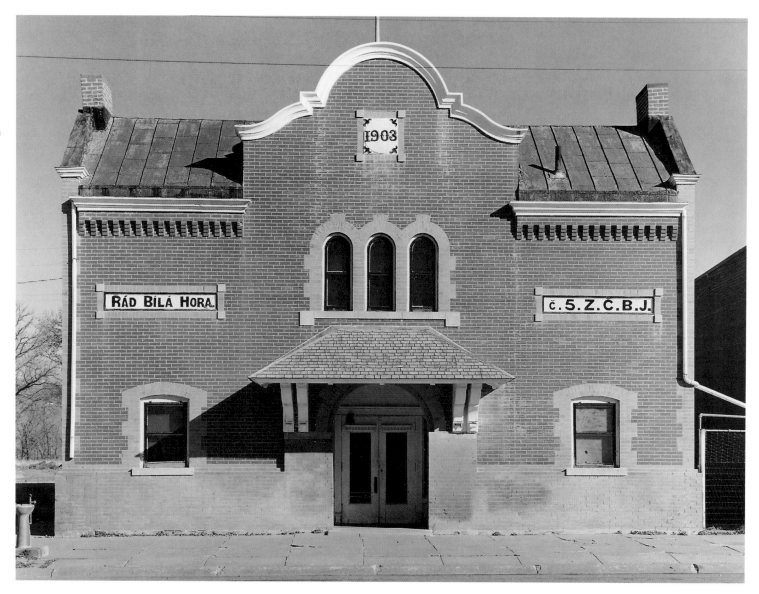

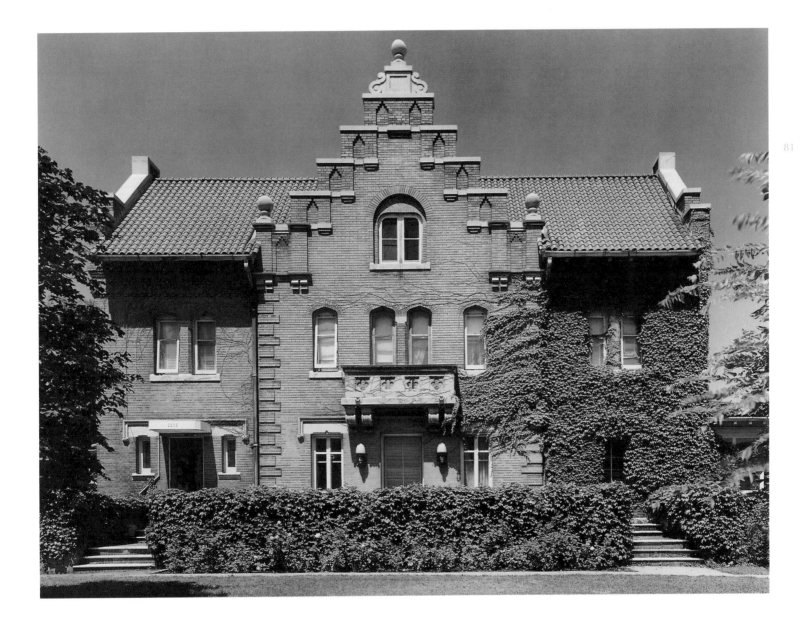

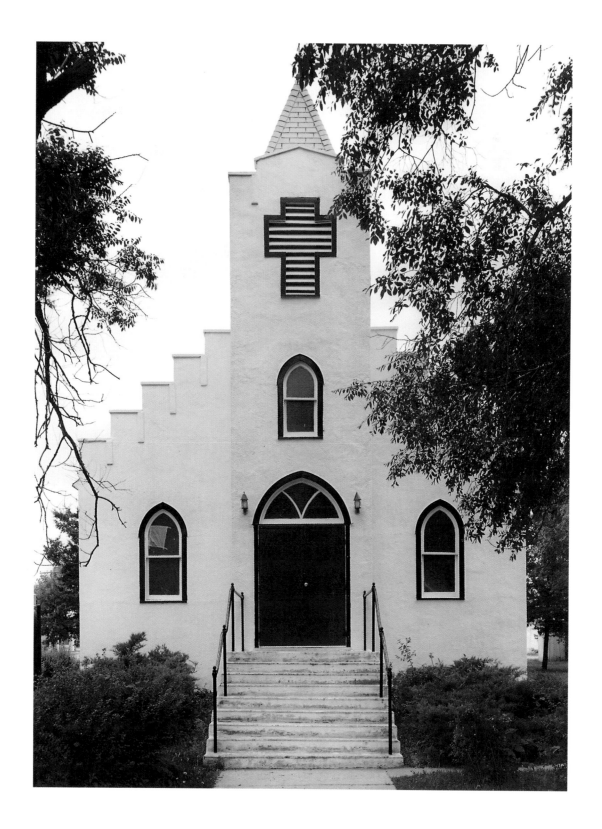

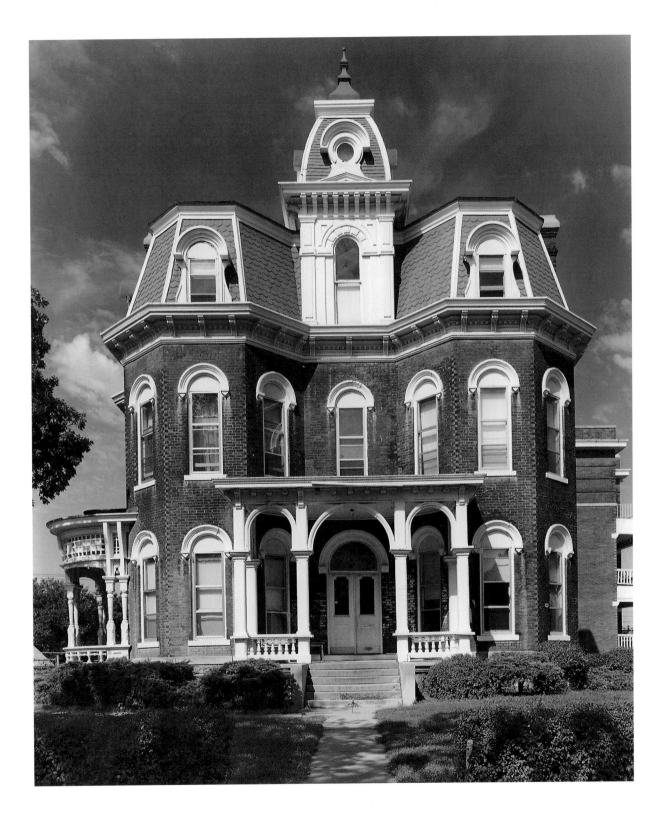

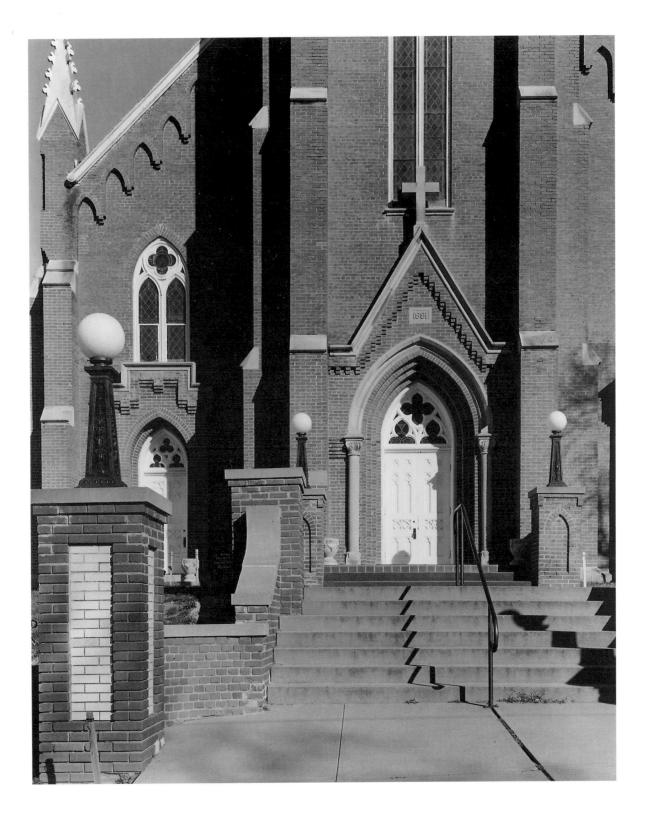

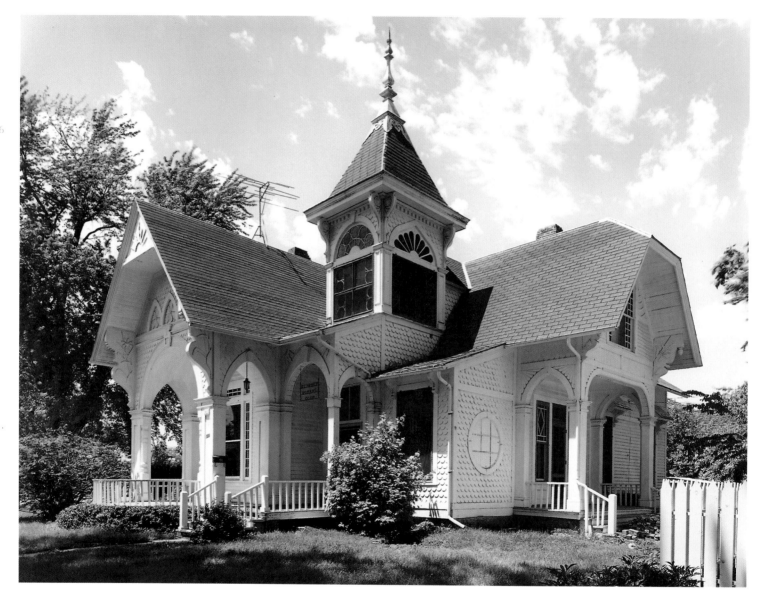

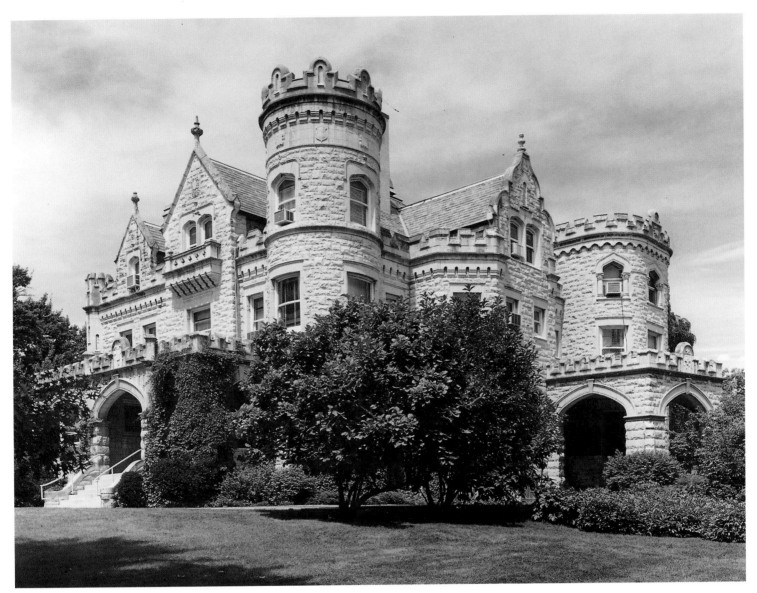

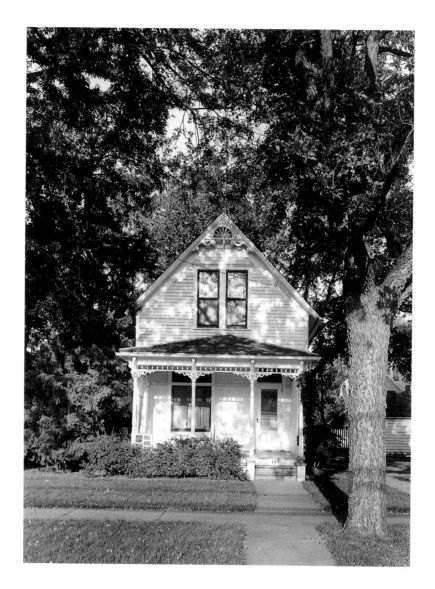

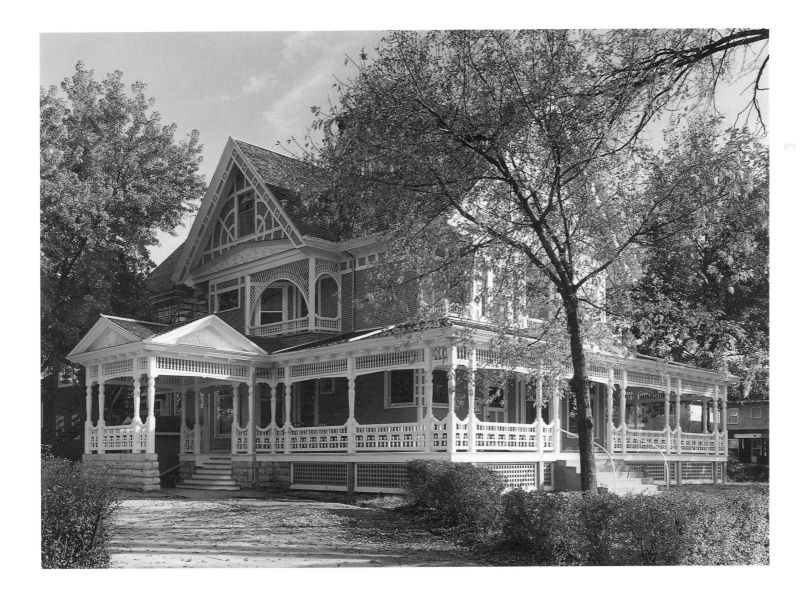

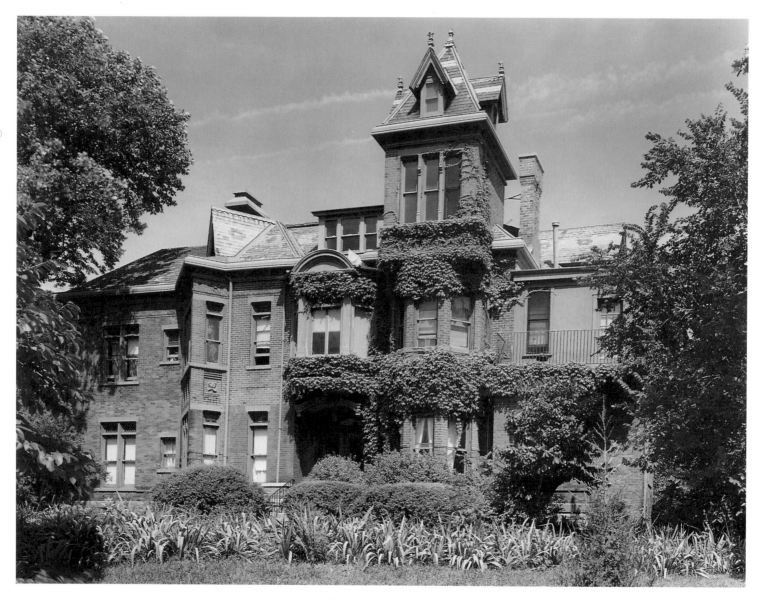

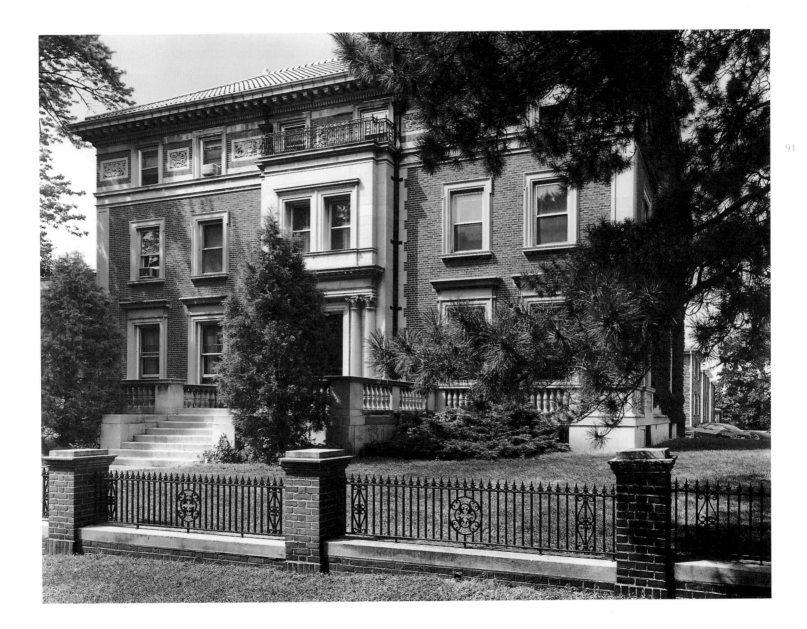

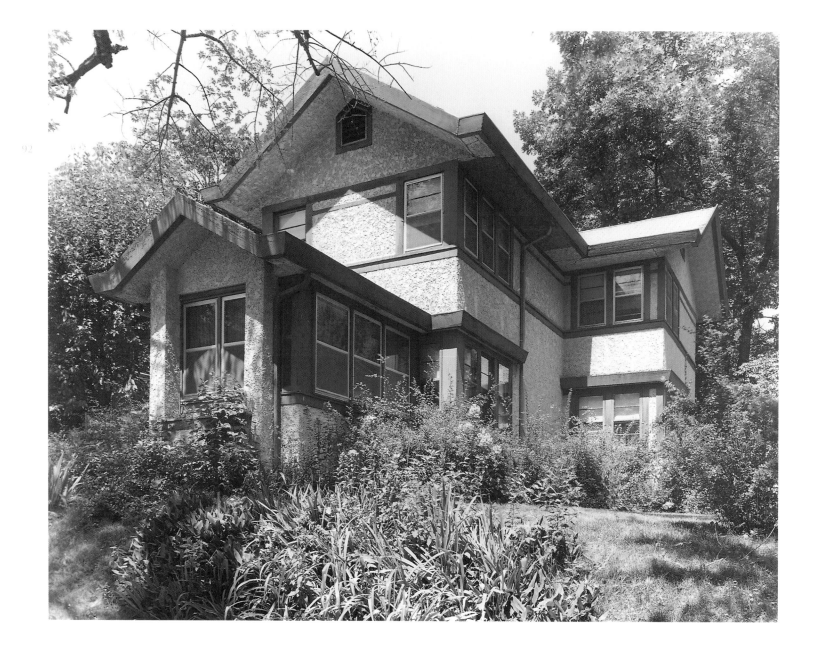

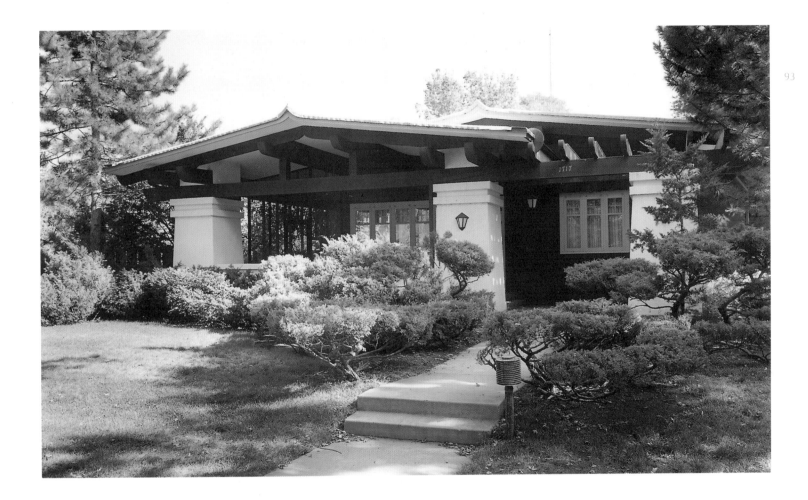

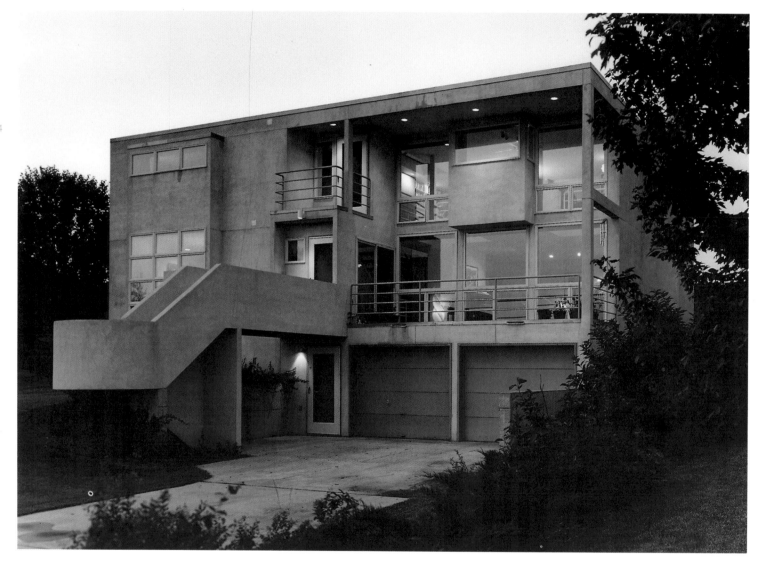

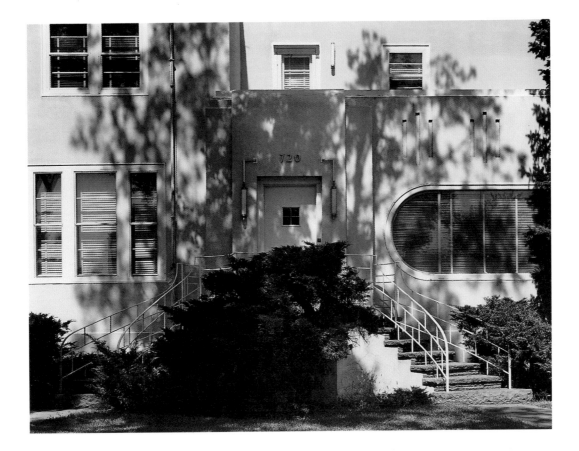

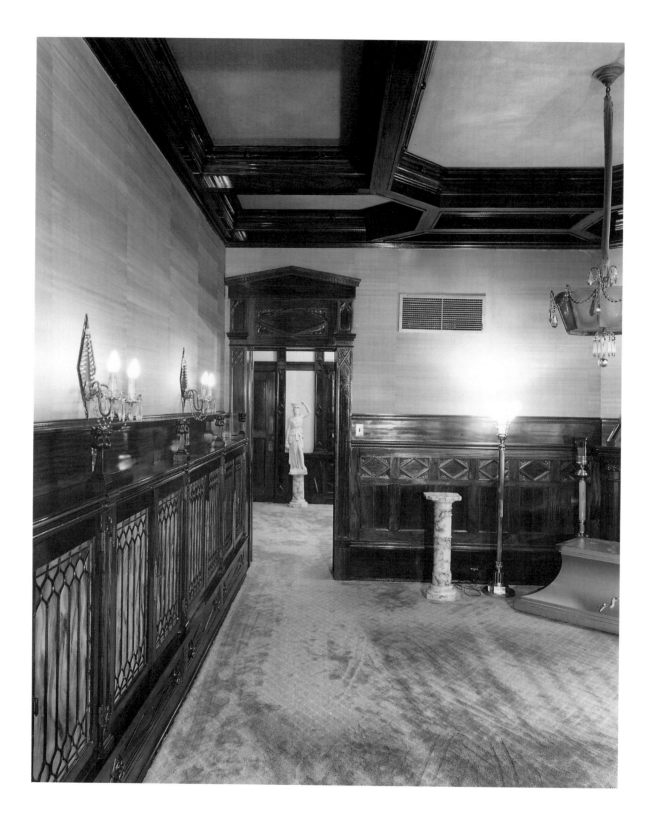

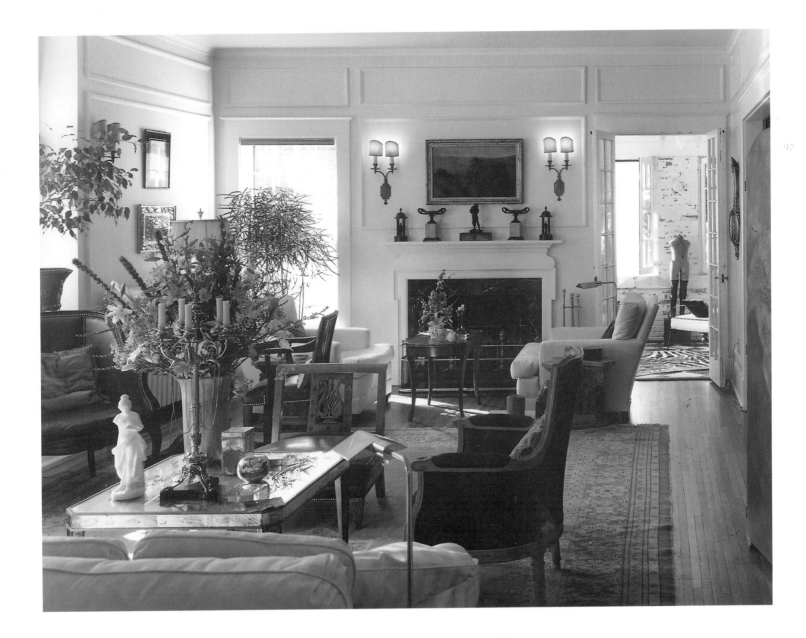

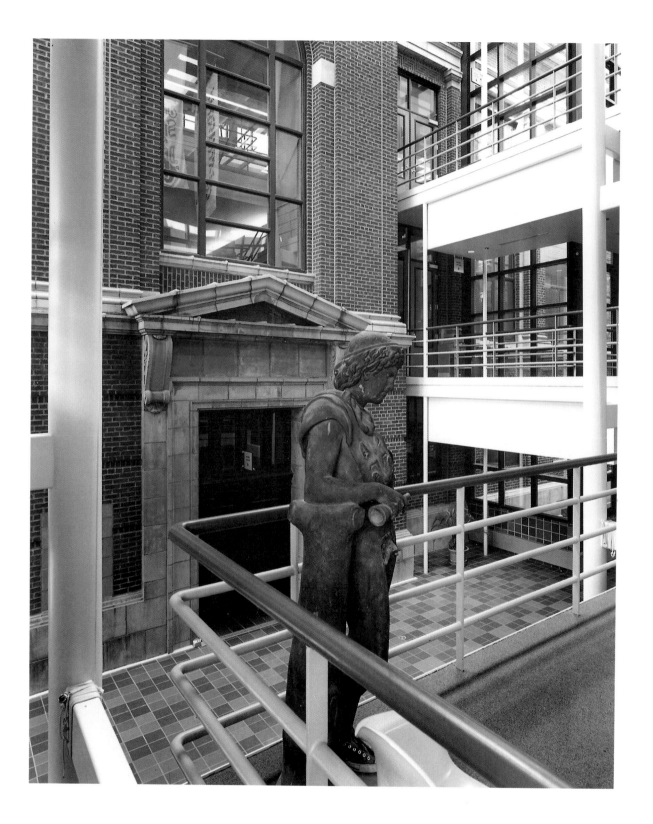

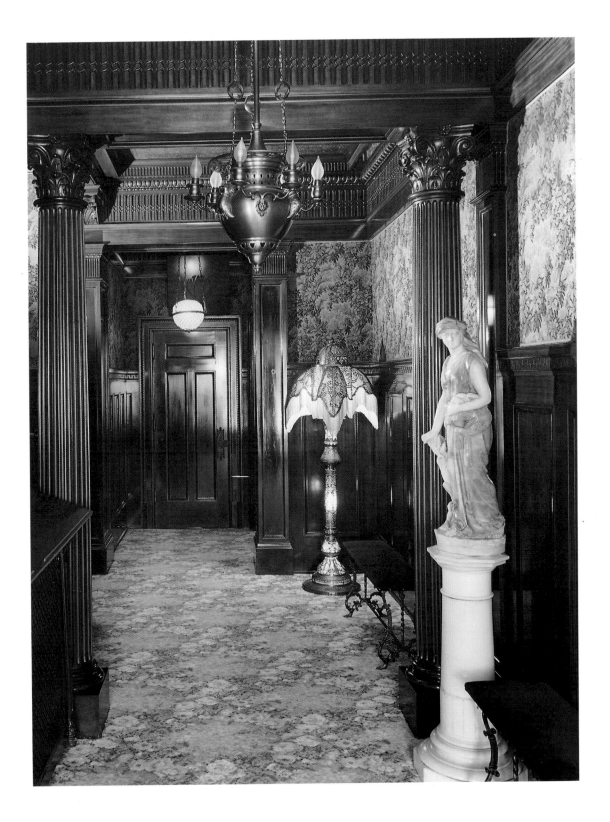

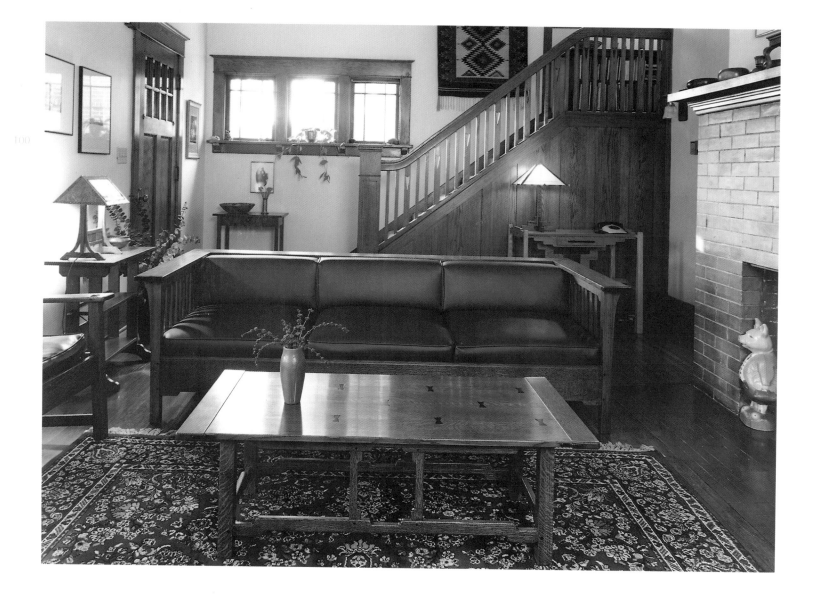

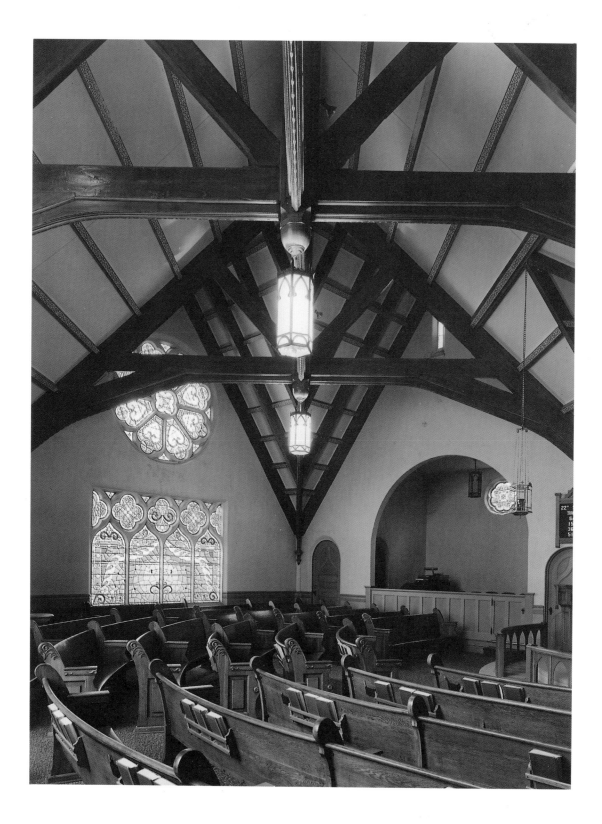

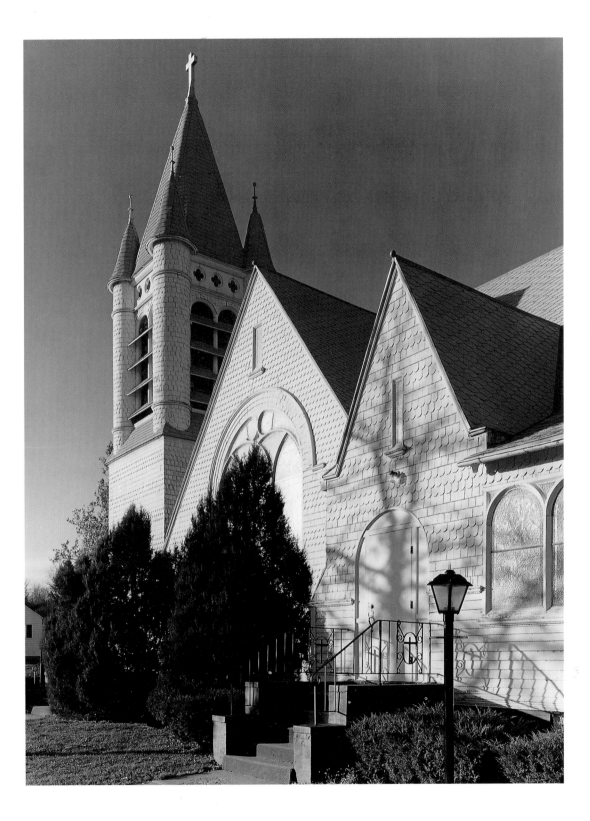

105

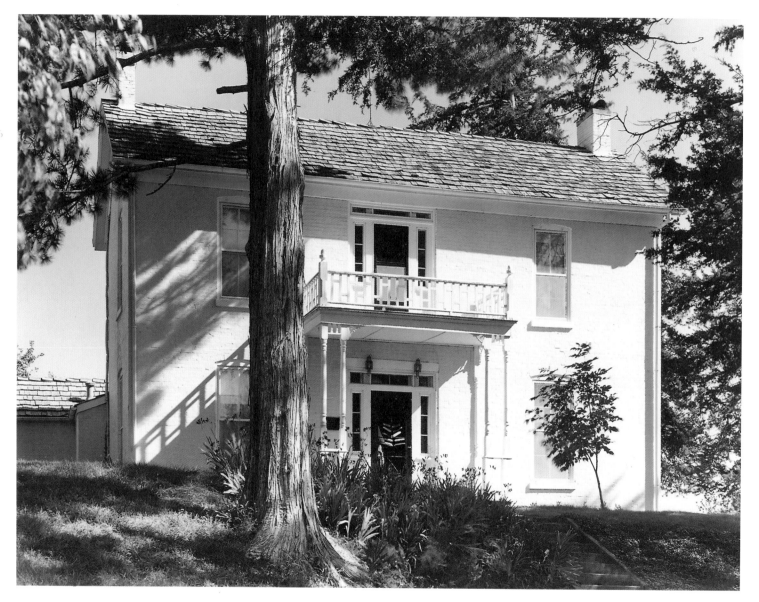

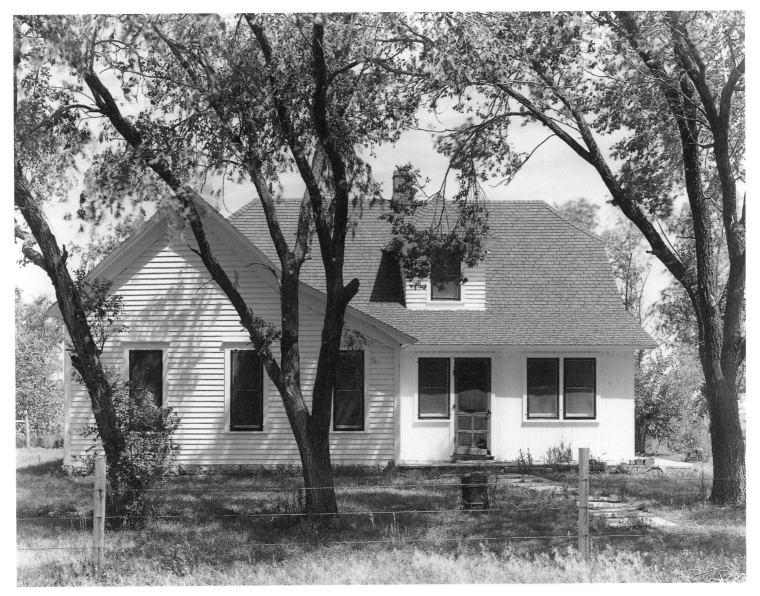

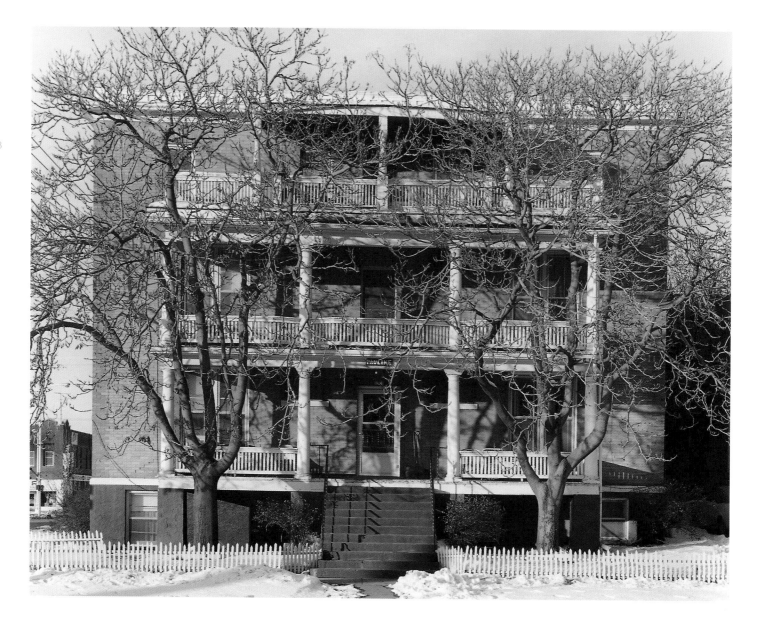

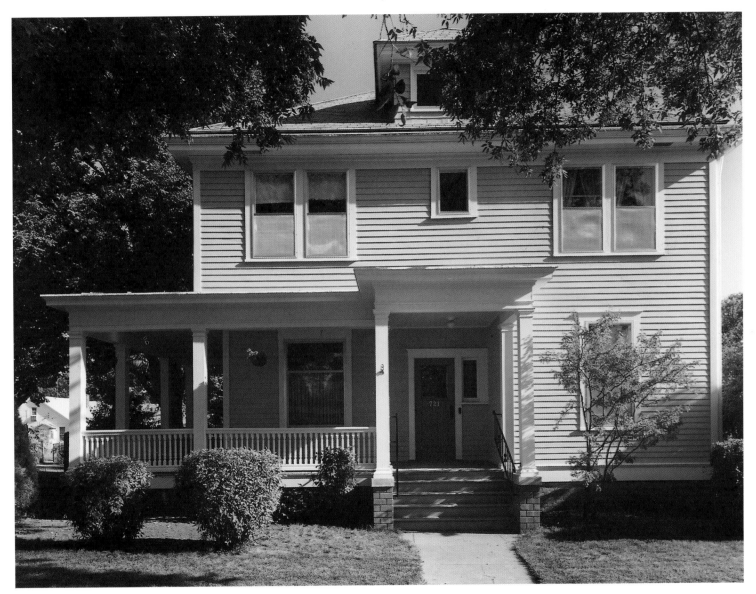

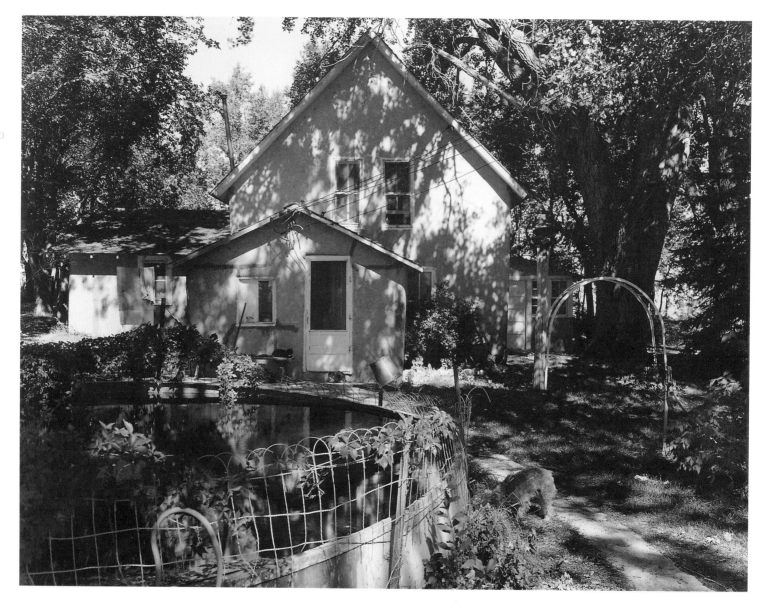

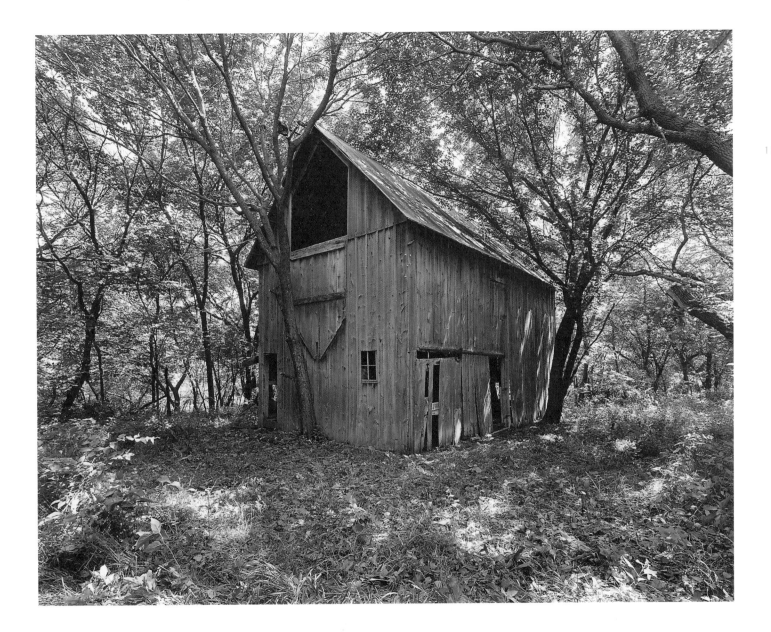

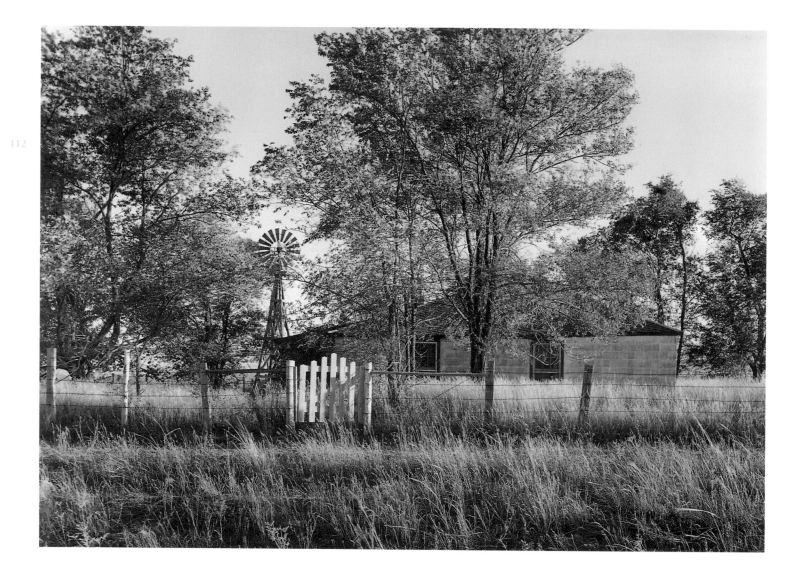

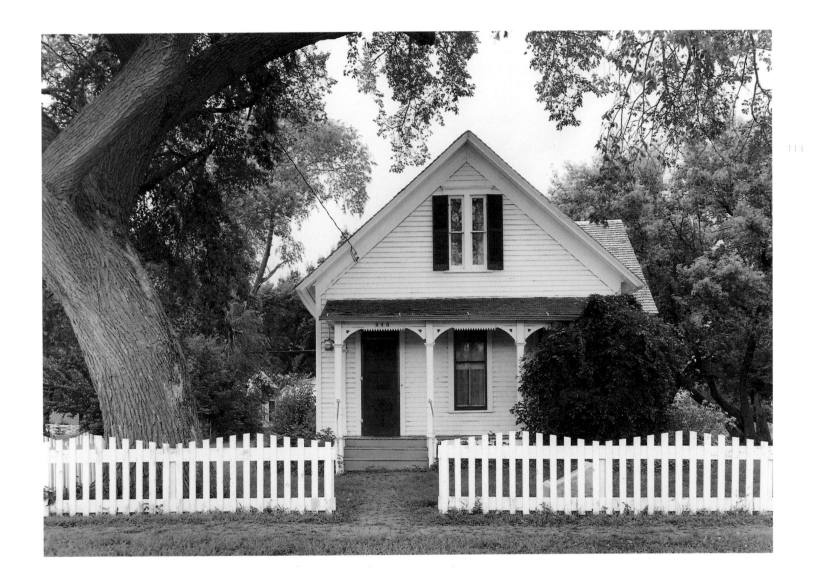

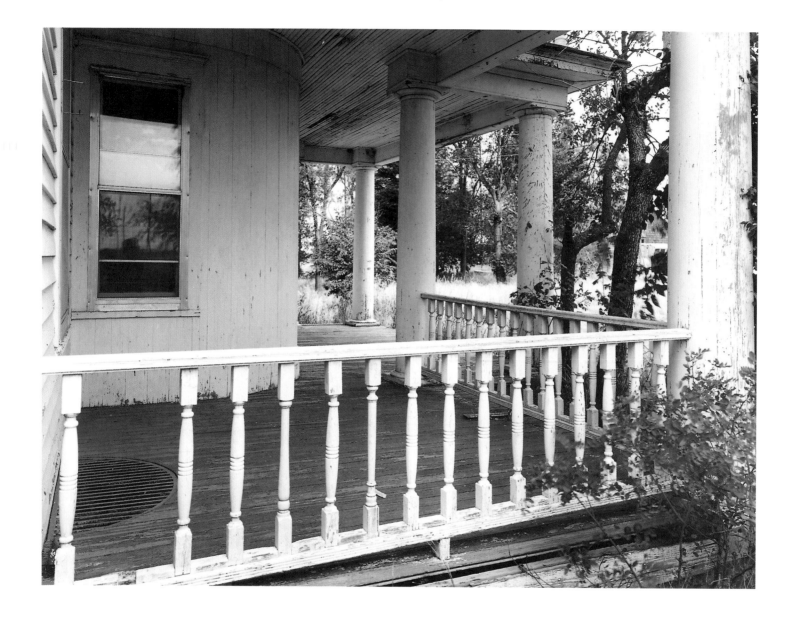

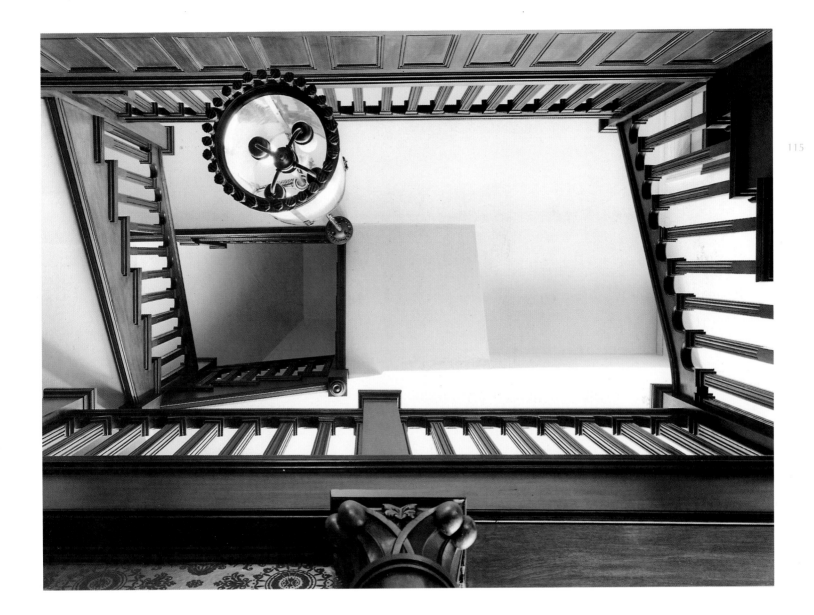

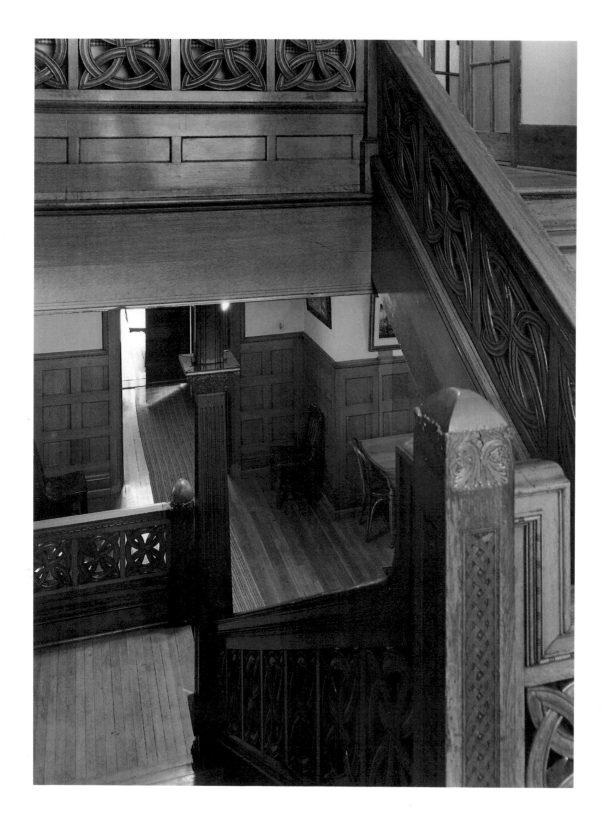

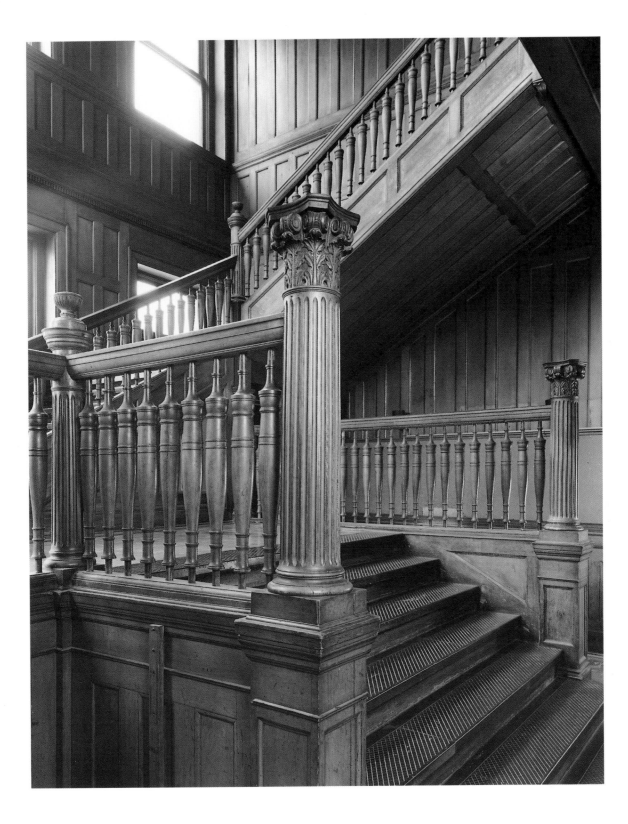

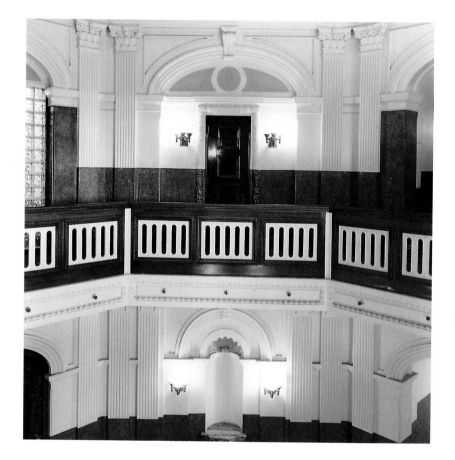

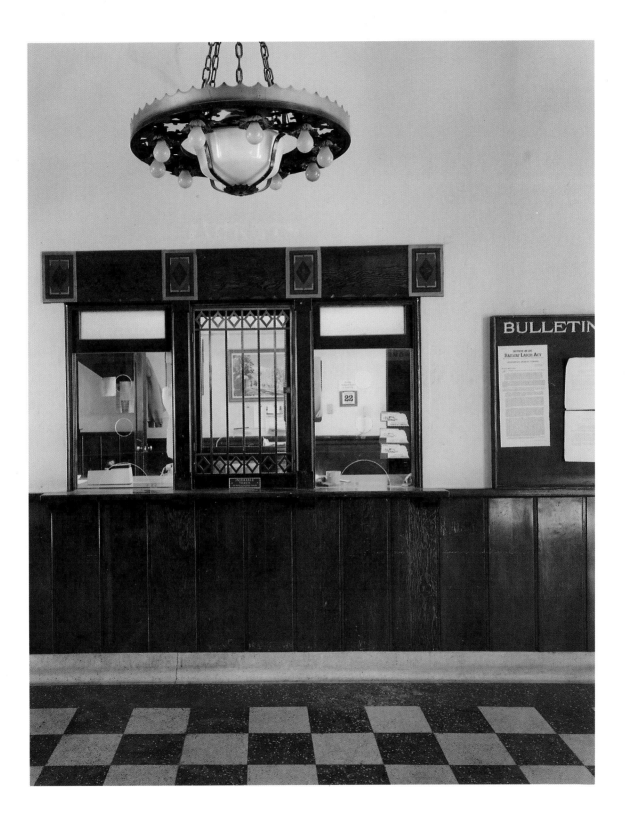

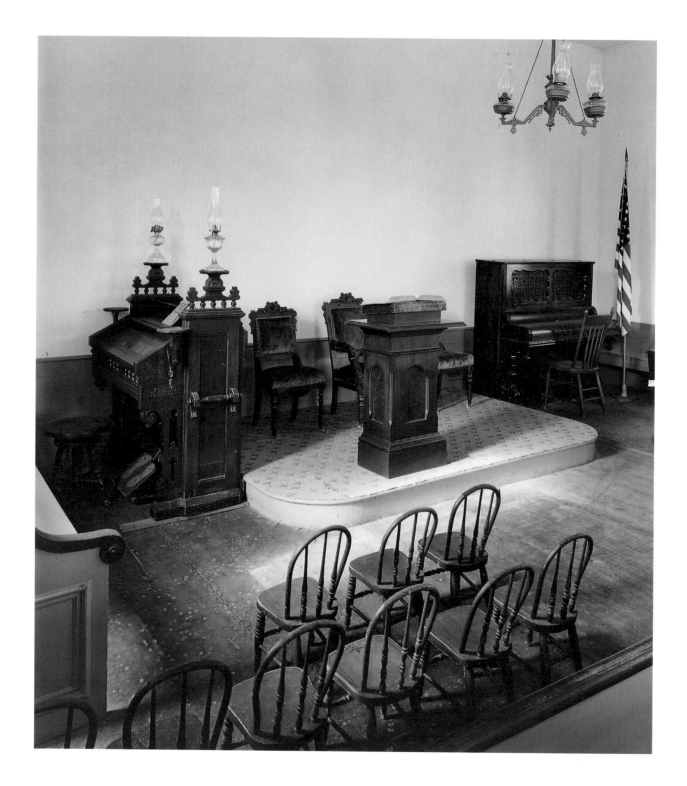

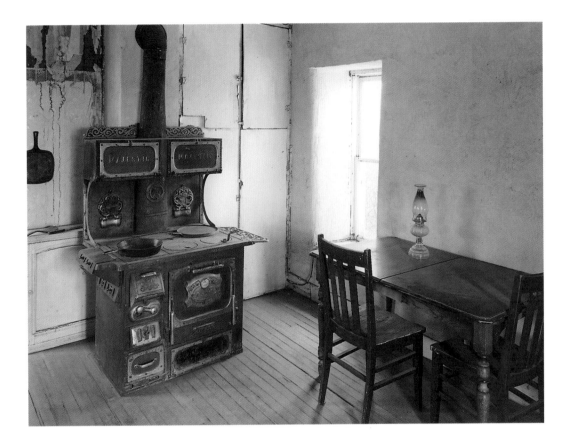

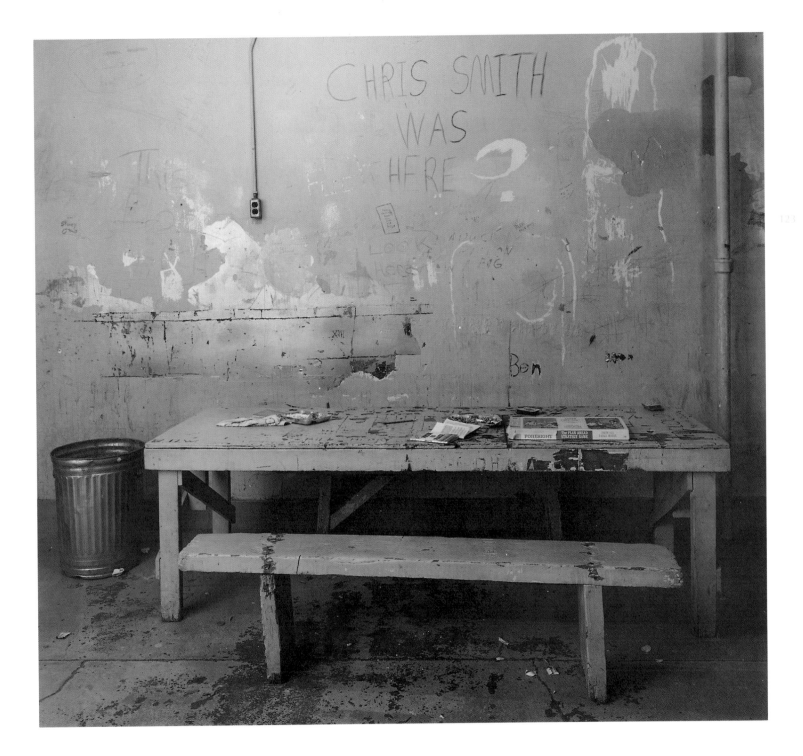

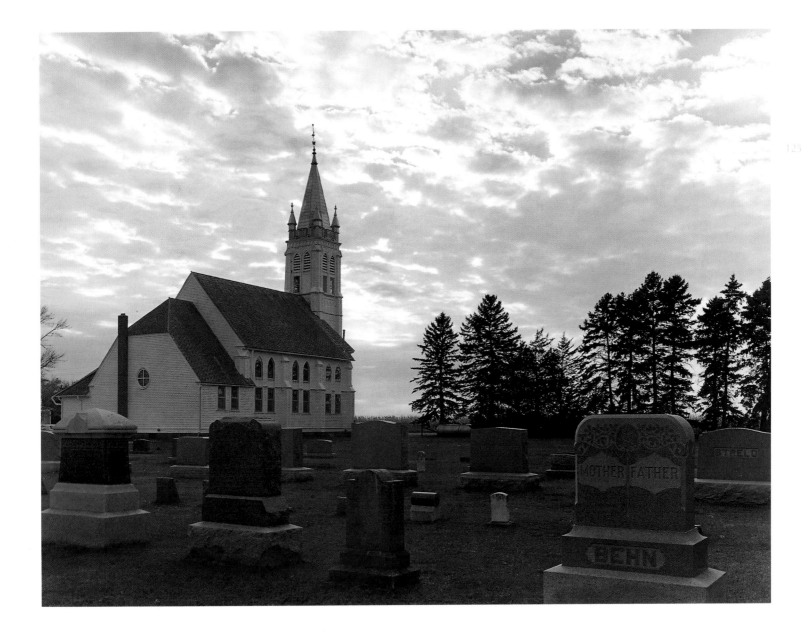

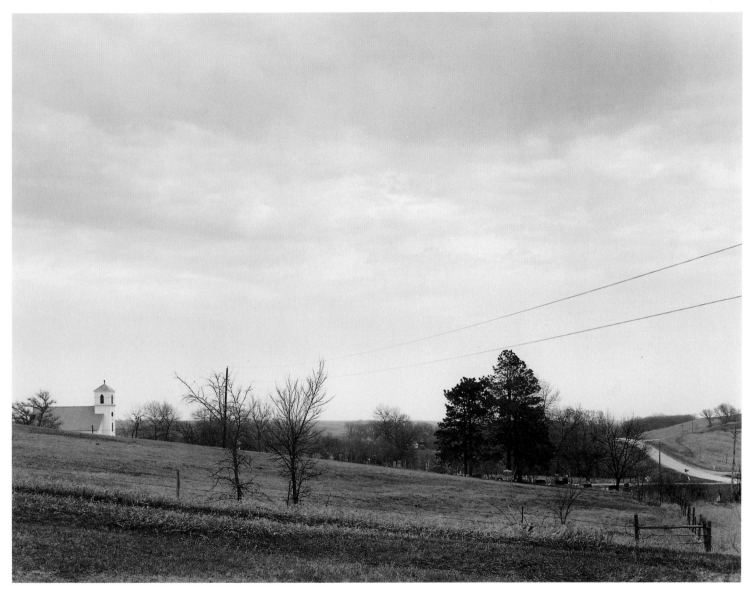

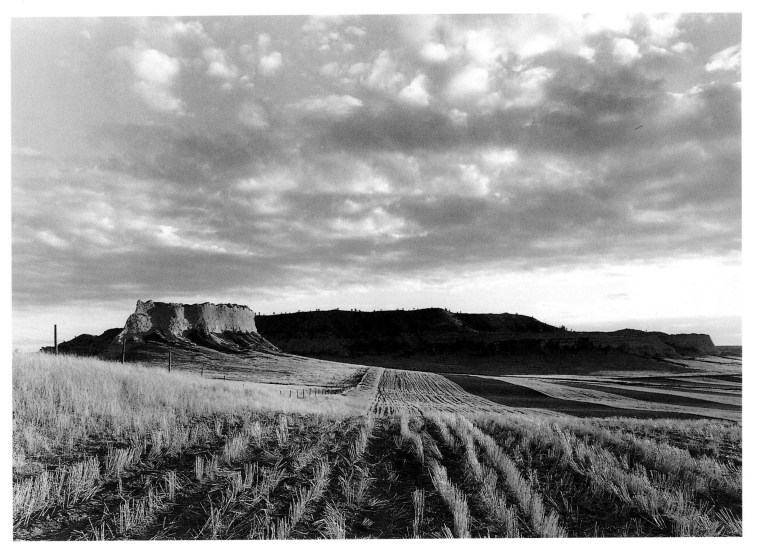

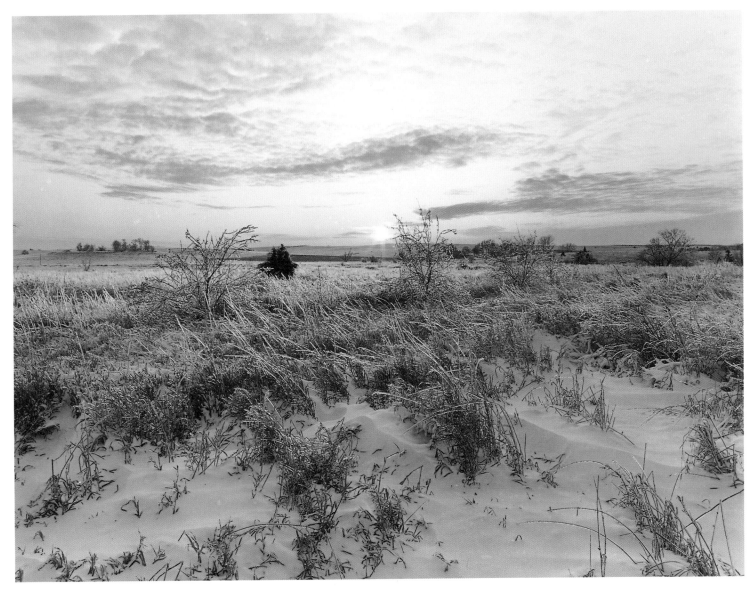

NOTES

Edward F. Zimmer

These notes are intended to provide information on the buildings shown rather than to comment on the photographs. Most of the information is drawn from the files of the Nebraska Historic Building Survey at the Nebraska State Historical Society, but factual errors should be credited to misinterpretation by this writer. Debra Buchholz McWilliams of the Nebraska State Historical Society staff provided invaluable assistance in locating information on these dozens of buildings among the tens of thousands recorded in Nebraska Historic Building Survey. *Historic Places: The National Register in Nebraska*, published in 1989 as a joint issue of *Nebraskaland Magazine* and *Nebraska History*, was also useful. Photographs are referred to by page number.

1
Dome Rock, Scotts Bluff County.
Photograph made January 1981.

3
Landscape, Sioux County.
Photograph made September 1978.

5
Waggy Ranch, Morrill County.
The limestone house and barn, situated in a narrow valley, were built in about 1900 by Adam Waggy. Photograph made September 1978.

7
Perrin Sod House, Cherry County.
This four-room sod building, constructed in 1912, was the farmhouse of James and Alice Perrin. Photograph made September 1978.

8
Gillespie House, Cheyenne County.
Homesteader John Gillespie built this limestone farmhouse in about 1909. Photograph made September 1978.

9
Immaculate Conception Church, Montrose, Sioux County.
This small, stuccoed frame building was constructed as a Roman Catholic mission church in 1887. The steep pitch of its gable roof is echoed in the entry porch and chancel ell, and re-echoed in the peaks above the tall windows. Photograph made September 1978.

10
Immaculate Conception Church, Montrose, Sioux County.
See note 9. Photograph made September 1978.

11
Kidney Farmstead, Cheyenne County.
William Kidney, an Irish immigrant, built his six-room farmhouse of local stone in 1892, and his barn (right foreground) of the same material in 1894. Photograph made September 1978.

12
Dane Church, Webster County.
The St. Stephenie Scandanavian Evangelical Lutheran Church, better known as the Dane Church, was built soon after a tornado destroyed the congregation's previous church in 1927. The new church closely follows the lines of the earlier building, which had probably been built in the late nineteenth century. The Dane Church is listed on the National Register of Historic Places as part of the Willa Cather Thematic Group. Photograph made July 1978.

13
Wertz Barn, Sioux County.
Henry Wertz, a carpenter and farmer, built this barn for his own use in the period 1900–1910. He proudly displayed his craft in the decorative shinglework of the walls, large dormers, and ventilator set diagonally to the ridges of the other roofs. Photograph made September 1978.

14
Frank House, Kearney, Buffalo County.
George W. Frank, a wealthy businessman and industrialist, built his house in 1889 in an exclusive suburb that he was developing outside Kearney. His son, George, Jr., served as architect. The Colorado sandstone building, one of the best examples of the Richardson Romanesque style of architecture in

the state, is undergoing a gradual and painstaking restoration under the sponsorship of Kearney State College, on whose campus it stands. Since this photograph was made, a red tile roof has been reinstalled. The Frank House is listed on the National Register of Historic Places. Photograph made October 1978.

15
Santee Church, Santee, Knox County. Built by Episcopalians as a mission to the Sioux on the Santee Reservation, this 1884 church survives in remarkably unaltered condition. The board-and-batten exterior siding is especially rare on a Nebraska church. Photograph made October 1978.

16
Bow Valley Mills, Cedar County. This water-powered flour mill on Bow Creek near St. Helena was built in 1868 by Lewis E. Jones, a Welsh immigrant. Flour produced here was shipped as far as Montana by Missouri River steamboats. Jones also published Cedar County's first newspaper, on a press he had brought from St. Louis, and constructed the county's first sawmill. Bow Valley Mills is listed on the National Register of Historic Places. Photograph made October 1978.

17
Grace Protestant Episcopal Church, Red Cloud, Webster County. This wood-frame Gothic Revival church of 1884 has seen changes in location and exterior appearance, having been moved to its present site in 1891 and brick-veneered after 1922.

Yet the interior retains much of its original appearance. The horizontal tongue-and-groove boarding of the walls and exposed scissor-truss roof, with the trusses more closely spaced over the chancel, are especially noteworthy. Willa Cather, although raised a Baptist, joined this church in 1922 and mentions it in her novel *A Lost Lady*. The church is listed on the National Register of Historic Places. Photograph made July 1978.

18
Krueger House, Cheyenne County. A farmhouse constructed in about 1900 of local stone, this building has survived as a farm outbuilding. Photograph made September 1978.

19
Emmanuel Lutheran Church, Dakota City, Dakota County. This remarkably early building was constructed in 1860 by Augustus T. Haase, a church member and carpenter. It is one of a handful of Nebraska buildings displaying the Greek Revival style prevalent in the middle third of the nineteenth century. Note the low-pitched gable roof with eaves returns suggesting a classical pediment, flat cornices above the door and windows, and blocky tower framed by simple pilasters at the corners. The church is listed on the National Register of Historic Places. Photograph made October 1978.

20
House, Nysted, Howard County. A steep façade gable dominates the front of this little house, but its builder did not feel compelled to align either the porch or the first-floor windows with the gable above. Photograph made April 1978.

21
Brown-McLaughlin House, Lincoln, Lancaster County. Guy A. Brown, state librarian as well as clerk and reporter for the State Supreme Court, built his large, blocky house in about 1885. William McLaughlin, a real estate dealer and county treasurer, bought the house in 1894 and lived there for many years. Noteworthy features of the well-preserved building include the wrap-around porch with turned spindles and posts and the recessed second-story porch with arched openings. Photograph made June 1978.

22
Merna State Bank, Merna, Custer County. This turn-of-the-century building contains the bank in the prime corner office and additional, well-preserved storefronts along the street, united by a bold cornice. Photograph made June 1979.

23
Andre's Store, Petersburg, Boone County. This double storefront, built in about 1903, still houses a general store. Two gable roofs cover the building and are partially masked by a false front. Photograph made May 1979.

24
Nutter Octagonal House, near Gibbon, Buffalo County. Built in the late nineteenth century, this house is one of the few examples in Nebraska of the eccentric, octagonal

house plan. An early photograph shows the Nutter house encircled by a porch. Octagonal houses were promoted in the mid-nineteenth century as efficient in materials, labor, and space. Photograph made June 1979.

25
Starke Barn, Webster County.
A three-level structure measuring 130 feet in diameter, this dairy barn was built in 1902–3 by the brothers Conrad, Ernest, Bill, and Chris Starke. Like octagonal houses, round barns were promoted by agricultural reformers and were adopted for their efficiency by innovative farmers. The Starke barn is listed on the National Register of Historic Places. Photograph made July 1978.

26
Livestock and Exhibition Pavilion, Bloomfield, Knox County.
This octagonal building was erected on the county fairgrounds between 1920 and 1923. Photograph made October 1978.

27
Hall County Courthouse, Grand Island.
Thomas Rogers Kimball of Omaha was the architect of this stately Beaux-Arts-style building, completed in 1904. The view shows the rotunda ceiling. (See also note 118.) Kimball's contributions to Nebraska's architectural heritage include the old Omaha Public Library and St. Cecilia's Cathedral in Omaha. As professional adviser to the Nebraska Capitol Commission, he played an influential role in the selection of Bertram G. Goodhue's brilliant design for

the state capitol. The Hall County courthouse is listed on the National Register of Historic Places. Photograph made September 1978.

28
Adventist Church, Lincoln, Lancaster County.
Built in 1894 and demolished after its replacement by a new church in 1978, this wood-frame building served the Seventh-Day Adventists of College View, a town organized in 1891 around that denomination's Union College. The building had a seating capacity of 1,175. Photograph made March 1978.

29
Chautauqua Pavilion, Hastings, Adams County.
An open-sided octagonal structure that seats 3,500, this pavilion was built in 1907 to house summer Chautauqua assemblies. The pavilion is listed on the National Register of Historic Places. Photograph made September 1978.

30
First Presbyterian Church, Hastings, Adams County.
Photograph made September 1978.

31
Santee Church, Santee, Knox County. See note 15. The interior of this 1884 church, like the exterior, retains most of its original appearance. Photograph made October 1978.

32
Nye House, Omaha, Douglas County. Built for Frank Nye in 1887, this Richardson Romanesque house had a stone first story and brick above. The structure was demolished in 1980. Photograph made August 1978.

33
Nicholson Sod House, Sioux County. Built in 1909 by ranchers Bill and Alvin Nicholson, this sod house has a three-room floor plan. Photograph made September 1978.

34
Salem Swedish Methodist Episcopal Church complex, near Axtell, Kearney County.
This group of buildings consists of a frame parsonage (left), school (center), and Carpenter Gothic-style church. The parsonage began as a small house, built in 1883, which was altered and enlarged to its present form between 1903 and 1906. The school was moved to this site in 1978 from its original location forty miles away in the Swedish town of Carter, where it was built in 1910. The church, with a side tower and spire, was constructed in 1898. The complex is listed on the National Register of Historic Places. Photograph made June 1979.

35
Johnson County Courthouse, Tecumseh.
William Gray of Lincoln was the architect of this building, constructed in 1888–89 of brick on a high stone basement, with extensive terra cotta ornament. It is an archetypical county courthouse-on-the-square, and is listed on the National Register of Historic Places. Photograph made February 1988.

36
First Baptist Church, Tekamah, Burt County.
This church has been modified and extended over a period of years, but the

oldest portion is thought to date from 1858. Photograph made April 1979.

37
House, Abie, Butler County.
This frame house displays the longitudinal orientation to the street and side entry characteristic of early houses built in Nebraska by Czech immigrants. Typical houses in the rural villages of the old country did not face the road, but instead faced a small courtyard surrounded by farm buildings. In America the courtyards were not built, but the orientation and side entry persisted. This house is thought to be the former rectory of the first Czech Catholic church in Nebraska, established in 1876. Photograph made April 1979.

38
Main Street, Comstock, Custer County.
Comstock was established in about 1900 as a railroad town. Its Main Street displays excellent examples of small-town commercial buildings, including some that predate the town's founding. In the background is the Wescott, Gibbons and Bragg's Store, built in nearby Wescott in 1888 and moved to Comstock in 1900. Note the bracketed cornice on the false front. The former Citizens State Bank has a fine terra cotta doorway bearing the dates 1906, probably the year of the bank's founding, and 1914, presumably the date of the building's construction. Wescott, Gibbons and Bragg's Store is listed on the National Register of Historic Places. Photograph made June 1979.

39
Main Street, Comstock, Custer County. See note 38. Photograph made June 1979.

40
I.O.O.F. Building (Old High School), Gibbon, Buffalo County.
This Italianate-style commercial block, with a fraternal order's meeting hall on the upper floor, had its origins a few blocks away as the Gibbon High School of 1884. The building was moved and converted to a commercial structure in 1908 by removing the original belfry and installing storefronts. Photograph made June 1979.

41
Store, Nysted, Howard County.
This long, narrow store with a tall false front was probably built in about 1900. Photograph made April 1979.

43
Tecumseh City Hall, Johnson County.
Built in 1889, this brick public building has a carefully balanced but asymmetrical façade, with the window heights and cornice decorations differing on either side of the central tower. Wright Morris photographed this building in 1947 and published the image in his God's Country and My People. At that time the bricked-in area on the left of the façade still contained garage doors for fire engines. The city hall is listed on the National Register of Historic Places. Photograph made February 1988.

44
Saint Mary's Cathedral, Grand Island, Hall County.
This limestone Roman Catholic cathedral, designed by Henry W. Brinkman

and J. Stanley Hagan of Emporia, Kansas, and built in 1926–28, is a fine example of Gothic Revival architecture. The main altar is carved of Italian marble. Photograph made September 1978.

45
Elevator, Hastings, Adams County.
This reinforced concrete structure perches among the tracks in the Hastings railyard. The stiltlike base permitted delivery of grain to the elevator, from which it would be transferred to rail cars. Photograph made September 1978.

47
Nebraska State Capitol, Lincoln, Lancaster County.
Bertram Grosvenor Goodhue's masterpiece was constructed between 1922 and 1932. The view shown is the north façade as seen from Centennial Mall. The capitol is a National Historic Landmark. Photograph made June 1984.

48
Far-Mar-Co Grain Elevators, Lincoln, Lancaster County.
Built in 1949, with additions in 1951 and 1953, the elevators had to be repaired and reconstructed after a fatal explosion in 1976. The individual reinforced-concrete cylinders, of which there are more than one hundred, measure 24 feet in diameter and about 125 feet tall. Chalmers and Borton of Lincoln were the engineers and contractors for the original construction. Photograph made October 1977.

49
American Charter Building, Lincoln, Lancaster County.
Reflected in the mirrored-glass "skin" of this modern office building are the Art Deco–style Union Bus Depot, designed by Davis and Wilson of Lincoln and built in about 1930, and the Nebraska State Capitol. In the background is the sixteen-story Sharp Building, constructed in 1927 during Lincoln's modest skyscraper boom. Photograph made June 1984.

50
Arch with Capitol, Lincoln, Lancaster County.
The four-hundred-foot capitol tower dominates the Lincoln cityscape and is visible from much of the surrounding rural area. This view is from the northwest. Photograph made March 1981.

51
Centennial Mall, Lincoln, Lancaster County.
The north axis of the state capitol, 15th Street, was developed as a landscaped pedestrian mall in the late 1960s, commemorating Nebraska's centennial in 1967. The Lincoln architectural firm of Clark Enersen designed the mall. Photograph made July 1984.

52
Stuart Building, Lincoln, Lancaster County.
Designed by Davis and Wilson, a leading Lincoln architectural firm, the Stuart Building was constructed between 1927 and 1929 for one and a half million dollars. Built as a mixed-use structure, it combined an eighteen-hundred-seat movie theater, ground floor retail shops, office tower, and a private club in the penthouse. All

those uses continue except that the office floors are being converted to residences. Photograph made April 1979.

53
Downtown Lincoln, Lancaster County.
Looking northwest, this view includes, on the left, the eleven-story NBC Center, designed by I. M. Pei and Partners of New York City for the National Bank of Commerce. The Lincoln firm of Davis/Fenton/Stange/Darling collaborated on this project, which opened in 1976. Photograph made July 1984.

54
Aquila Court Building, Omaha, Douglas County.
Constructed in about 1923 from designs by the Chicago architects Holabird and Root, this mixed-use retail, office, and residential building was a project of the Chicago developers Charles and Raymond Cook. The U-shaped plan encloses a central courtyard. Aquila Court is listed on the National Register of Historic Places. Photograph made August 1978.

55
Saint Mary's Church, Lincoln, Lancaster County.
Begun for a Protestant congregation in 1888 but not completed until 1899, this Gothic Revival church became Lincoln's Catholic cathedral in 1904. The statue of Abraham Lincoln in the foreground, installed at the west entrance to the state capitol in 1912, was sculptured by Daniel Chester French, who also created the seated figure in the Lincoln Memorial in Washington, D.C. Photograph made April 1984.

56
Trinity Cathedral, Omaha, Douglas County.
The English architect Henry G. Harrison designed this Gothic Revival Episcopal cathedral, but never visited the site. Supervision of the execution of the design was left to an Omaha architect, Alfred R. Dufrene, who completed the building in 1883. The cathedral is listed on the National Register of Historic Places. Photograph made July 1978.

57
Saint Paul's Methodist Church, Lincoln, Lancaster County.
Replacing an earlier building that was destroyed by fire in 1899, Saint Paul's Methodist Church was designed by the Cincinnati architects Brown, Burton, and Davis and was dedicated in 1902. When it was completed, this brick High Victorian Gothic–style church had a sharp spire atop the belfry. Saint Paul's is viewed here from the north, across the construction site for the Centrum mall and garage. Photograph made May 1978.

58
Fontenelle Hotel, Omaha, Douglas County.
The Omaha architect Thomas R. Kimball designed the hotel, capping a ten-story brick tower with a three-story terra cotta display of Gothic decoration. The 1914 structure, named for Chief Logan Fontenelle of the Omaha Indians, has been demolished. Photograph made August 1978.

59
Redick Tower, Omaha, Douglas County.
Constructed as a combined office

tower and parking garage in 1930, this Art Deco building was designed by Joseph G. McArthur. The brick and terra cotta exterior covers a reinforced-concrete structure. The Redick Tower, which is listed on the National Register of Historic Places, has been converted into a luxury hotel. Photograph made August 1978.

60

J. L. Brandeis and Sons Department Store Building, Omaha, Douglas County.

Once the "flagship of the fleet of Brandeis department stores," this brick building with stone and terra cotta trim was designed by John Latenser, Sr., of Omaha and was erected in 1906. Two floors, of simpler but sympathetic design, were added in 1921. The building now houses retail shops and offices and is listed on the National Register of Historic Places. Photograph made August 1978.

61

First National Bank Building, Omaha, Douglas County.

A steel-frame building with brick and terra cotta cladding, this bank and office tower was designed by the Chicago firm Graham, Burnham and Company and was built in 1916. The Graham, Burnham firm succeeded D. H. Burnham and Company, continuing the practice of Daniel Burnham after the nationally prominent architect's death in 1912. The twin towers facing South 16th Street connect at the rear in a U-shape. The building is listed on the National Register of Historic Places. Photograph made August 1978.

62

Security Bank, Ponca, Dixon County. This two-story brick commercial block with a recessed corner entrance was built in 1892 for the Security Bank. The building's trim includes red sandstone arches above the upper windows and red-painted pressed-metal cornices, name plaque, and pediment. The bank is listed on the National Register of Historic Places within the Ponca Historic District. Photograph made October 1978.

63

Homan-Thayer Building, Omaha, Douglas County.

Constructed in 1889, this building is remarkable for its intact three-story cast-iron façade. Originally the ground floor and basement of the east half contained the "Natatorium," a public swimming pool and bathhouse. Photograph made August 1978.

64

Downtown Lincoln, Lancaster County. This view looks northeast from O Street to 13th Street. The Lincoln firm of Davis and Wilson were architects of the Penney's store at right (1950) and the Stuart Building in the center (1927–29), and as Davis/Fenton/Stange/Darling collaborated with I. M. Pei and Partners on the NBC Center at left (1976). Photograph taken January 1979.

65

Lincoln Mall from the Capitol, Lincoln, Lancaster County.

In 1983, J Street from the capitol west to the County-City Building was improved with a landscaped median, benches, shrubs, and streetlights, and was renamed the Lincoln Mall. This

joint project of the city government and business community was dedicated to the memory of Larry Enersen, a landscape architect who beautified the capital city through numerous projects, including Centennial Mall, which stretches from the capitol north to the campus of the University of Nebraska–Lincoln. Photograph made October 1983.

67

Bisbee School, Washington County. This rural schoolhouse had an unusual corner entry block topped by a belfry. The building was demolished in 1982. Photograph made April 1979.

68

Saint Boniface Church, Monterey, Cuming County.

The Roman Catholic parish in Monterey built its Gothic Revival–style church in 1924–25 for approximately $65,000. Plaster groin vaulting soars above the nave and side aisles. Photograph made October 1978.

69

Baum Iron Company Building, Omaha, Douglas County.

John R. Shaw built this four-story brick warehouse in 1880 for D. M. Steel and Company, wholesale grocers. The well-preserved storefront is of cast iron. The Baum Iron Company bought the building in 1905 and relocated there from across the street, where since 1888 Baum had been in the wholesale iron, steel, and heavy hardware business. Photograph made August 1978.

70
Saint Anthony's Church, Cuming County.
A stone above the entrance carries the name of the parish and two dates, 1866 and 1905. The former date is probably the year the parish was established; the latter is apparently the construction date. Photograph made October 1978.

71
Phillips House, Lincoln, Lancaster County.
Rollo O. Phillips, a townsite representative for the Burlington and Missouri River Railroad, built this large Colorado sandstone house in 1889–90 from designs by the Lincoln architect John H. W. Hawkins. In the right foreground is the "Castle's" matching carriage house. The property now contains ten luxury apartments. Photograph made April 1979.

72
Swedehome Evangelical Lutheran Church, Swedehome, Polk County.
This simplified Gothic Revival church served a Swedish congregation. Photograph made May 1979.

73
House, Swedehome, Polk County.
Small hipped-roof, square-plan houses such as this can be found not only in Nebraska's small towns but also in the immigrant neighborhoods of the larger towns and cities. Typically they date from the late nineteenth century. Photograph made May 1979.

75
Kearney Junior High School, Kearney, Buffalo County.
The Lincoln architects Davis and Wil-

son designed this Neoclassical Revival–style school in 1925. They were also responsible for several school buildings in Lincoln, including Everett Junior High School, which is similar. Photograph made June 1979.

76
Little-Atwood House, Lincoln, Lancaster County.
The president of the Lincoln Street Railway, Frank Little, probably had this house built in about 1894. That date, early for a Neoclassical Revival–style house, suggests that its designer (who is unknown) may have drawn inspiration from the buildings at the 1893 Columbian Exposition in Chicago rather than from Omaha's Trans-Mississippi Exposition of 1898–99, which was influential locally. Samuel Atwood, a stone mason and building contractor, purchased the property in 1900. The house is listed on the National Register of Historic Places as part of the Mount Emerald Historic District. Photograph made October 1987.

77
Kruse House, Grand Island, Hall County.
J. H. Fritz Kruse acquired this property in 1874 and probably built the small frame house soon after. Note the touch of elegance lent by the fluted pilasters and triangular pediment that frame the entry. Photograph made September 1979.

78
Folly Theater, Garland, Seward County.
A small but very substantial and digni-

fied building, the Folly employs Roman details such as the semicircular lunette with crisscrossed muntins, usually reserved for large public structures. Photograph made April 1988.

79
Telbasta Store, Telbasta, Washington County.
This small frame general store at a rural crossroads was built in 1903 by Ed Shafersman. The semicircular false front resembles, in simplified form, the Czech Rococo tradition displayed in such buildings as the Z.C.B.J. Hall in Verdigre. (See note 80.) Photograph made April 1979.

80
Rad Bila Hora (Z.C.B.J. Hall), Verdigre, Knox County.
Built in 1903 by W. C. Montford from designs by an architect known to us only as Staviteli, this brick structure housed the Bila Hora (White Mountain) lodge of the Z.C.B.J., a Czech fraternal order, and also served as Verdigre's opera house. The ornate façade gable reflects a continuation in America of the Czech Rococo Revival style. This building is listed on the National Register of Historic Places. Photograph made October 1978.

81
Kimball House, Omaha, Douglas County.
The Omaha architect Thomas R. Kimball designed this eclectic brick house in 1904 for his widowed mother, Mary, and his sister Arabel. Mary Kimball was an active suffragist, club woman, and founder of the Omaha Creche, an orphanage. Photograph made August 1978.

82

Immanuel Lutheran Church, Merna, Custer County.

This small church is distinctive for its stepped gable end. Photograph made June 1979.

83

Cornish House, Omaha, Douglas County.

Built in 1886, this brick house with scalloped slates on its mansard roofs is one of the finest French Second Empire–style mansions in Nebraska. Colonel Joel N. Cornish, the original owner, was a lawyer, businessman, and banker. The house is listed on the National Register of Historic Places. Photograph made August 1978.

85

St. Mary's Church, West Point, Cuming County.

This Gothic Revival–style brick Catholic church was built in 1891 and remodeled and expanded in 1928. Photograph made October 1978.

86

Hanson-Downing House, Kearney, Buffalo County.

Charles E. Hanson, a businessman, built this fanciful Queen Anne–style cottage in 1886. The house is a virtual catalog of wooden decorative motifs and techniques. It is listed on the National Register of Historic Places. Photograph made June 1979.

87

Joslyn House, Omaha, Douglas County.

The Omaha businessman and philanthropist George A. Joslyn and his wife, Sarah, had this thirty-five-room "castle" built in 1902 from designs by the architect John McDonald of Omaha.

The cost of construction was $250,000. The house is listed on the National Register of Historic Places. Photograph made August 1978.

88

House, Hastings, Adams County.

This late-nineteenth-century house displays in its decorated porch and gable screen the kind of ornate millwork mass-produced in factories of that time. Photograph made September 1978.

89

Yates House, Lincoln, Lancaster County.

This large Queen Anne–style house was built in about 1893 for Charles E. Yates, telegraph superintendent for the Burlington and Missouri River Railroad. It is the finest wooden example of that style extant in Lincoln. The porches are especially noteworthy. The exterior of the house has undergone an exemplary restoration over a period of several years. Photograph made October 1987.

90

Mercer House, Omaha, Douglas County.

Built in 1883–85 for Dr. Samuel Mercer, this sprawling Queen Anne–style mansion exemplifies that style in its varied massing, decorative slate roof, and picturesque tower. The architect, Sidney Smith, achieved the coup of publishing his design for this house in the November 1885 issue of *Inland Architect and Builder*, a Chicago-based architectural magazine. Mercer was a leading Nebraska physician and found-

er of a hospital and a medical school. His house is listed on the National Register of Historic Places. Photograph made August 1978.

91

Metz House, Omaha, Douglas County. The Omaha architect George B. Prinz designed this thirty-seven-room Georgian Revival–style mansion for Charles E. Metz, a brewery owner. The construction in 1915 cost $175,000. Photograph made August 1978.

92

Forster House, Omaha, Douglas County.

The stuccoed wood-frame building, designed in 1916 by the Chicago architect Louis C. Bouchard, was the home of George T. Forster, a department store buyer and manager. The stuccoed exterior, banded windows, horizontal massing, and organic floor plan are characteristic of Prairie School architecture. Photograph made August 1978.

93

Loucks House, Grand Island, Hall County.

Built in about 1918 for William and Laura Loucks, this is one of the very few Japanese-influenced bungalows in Nebraska. Photograph made September 1978.

94

Eckhardt House, Lincoln, Lancaster County.

Jim Hille of Sinclair Hille and Associates was the architect for this reinforced-concrete house, built in 1982 near Holmes Lake in southeast Lincoln. The flat-roofed, boxy form; the frank, unadorned use of concrete; and the placement of windows according

to the interior plan rather than for exterior effect identify this house as one of Nebraska's few fully developed International-style residences. Photograph made June 1988.

95
Bartenbach House, Grand Island, Hall County.
Moderne-style houses are very rare in Nebraska. One of the best is this residence designed by the Grand Island architect Gordon Shattuck and constructed in 1937–38 for Mrs. H. J. Bartenbach. The project was a thorough remodeling and enlargement of a one-story house built in 1893. The Bartenbach House is listed on the National Register of Historic Places. Photograph made September 1978.

96
Withrell-Barton House, Omaha, Douglas County.
Designed by the Omaha architects Fisher and Lawrie and built in 1892, this mansion originally belonged to John Withrell, an English-born brick manufacturer and contractor. The house was used by the Heafey and Heafey Mortuary for many years. It has been demolished. Photograph made August 1978.

97
Prophet-Leland-Petersen House, Lincoln, Lancaster County.
C. A. Schaaf built this house in 1908 for Frank N. Prophet, manager of the Beatrice Creamery Company. In 1911 Dean and Clara Leland purchased the home. Mr. Leland was chaplain of cadets and pastor for the Presbyterian Church at the University of Nebraska. Christian Petersen now owns the house, which is listed on the National

Register of Historic Places within the Mount Emerald Historic District. Photograph made October 1988.

98
The Link, Architectural Hall, University of Nebraska at Lincoln, Lancaster County.
The architectural firm of Bahr Vermeer and Haecker, based in Lincoln and Omaha, designed the College of Architecture's expanded facility, which combines two existing buildings by means of this link. It was completed in 1987. Photograph made June 1988.

99
Withrell-Barton House, Omaha, Douglas County.
See note 96. Photograph made August 1978.

100
Rosenbaum-Bruhn House, Lincoln, Lancaster County.
Julius Rosenbaum, a wholesale jeweler, was the first owner and occupant of this house, built in 1911 by C. A. Schaaf. It is now the home of the photographer R. Bruhn and his family. The house reflects influence of the Arts and Crafts Movement, an effect that is reinforced by the Stickley-type furnishings collected, or in some cases constructed, by the current owner. Photograph made December 1988.

101
Rosenbaum-Bruhn House interior, Lincoln, Lancaster County.
See note 100. Photograph made December 1988.

102
Salem Evangelical Lutheran Church, Ponca, Dixon County.
Built in 1892, the Salem Church was an outstanding example of Shingle-style architecture. Note the unusual quarter-circle arrangement of pews and altar, the fine stained-glass windows, and the exposed-truss ceiling. The building was demolished and replaced with a new church in about 1979. Photograph made October 1978.

103
Salem Evangelical Lutheran Church, Ponca, Dixon County.
The exterior of the Salem Church was dominated by a corner tower with distinctive rounded pinnacles at the corners. The decorative cut shingles unified the complex exterior. See note 102. Photograph made October 1978.

104
Old Nebraska Bookstore block, Lincoln, Lancaster County.
This block next to Kimball Hall has been razed for the Lied Center for the Performing Arts. The three-story Oikema Apartments on the corner were built in 1916–17. Clark and Enersen of Lincoln designed the new façade for the bookstore west (right) of the apartments in 1972. Photograph made June 1984.

105
Architecture Hall (Old University Library), University of Nebraska–Lincoln, Lancaster County.
The oldest building standing on the UN–L campus, the old library was planned in 1891 by the Omaha architects Mendelssohn, Fisher, and Lawrie and was completed in 1895. The north wing, shown here, housed the library's

bookstacks. The building is listed on the National Register of Historic Places. Photograph made July 1984.

106

Cogswell House, Brownville, Nemaha County.

Built in 1868 in Brownville, one of Nebraska's earliest towns, this brick house first belonged to Anthony G. Cogswell. The handsome entry with sidelights and transom, echoed by the doorway to the balcony above, has the breadth and simplicity of the Greek Rivival style. The Cogswell House is listed on the National Register of Historic Places within the Brownville Historic District. Photograph made October 1977.

107

Pavelka Farmhouse, Webster County.

Joe Pavelka, a Czech farmer, moved a one-story, two-room house to this site after 1905, then in about 1911 added a one-and-a-half-story wing to bring the farmhouse to its present configuration. Willa Cather used this place as a setting in *My Ántonia*, calling it the Cuzak farmstead. The property is listed on the National Register of Historic Places as part of the Willa Cather Thematic Group. Photograph made July 1978.

108

Pauline Apartments, Lincoln, Lancaster County.

Built in 1909, this buff-brick apartment house has an unusual three-story porch. Photograph made January 1979.

109

Roeser House, Grand Island, Hall County.

Oscar Roeser, retailer, civic leader, and first-generation German-American, had this frame house built in 1908 by Henry Falldorf, a German immigrant and leading Grand Island contractor. The architect, Thomas R. Kimball of Omaha, combined features of the then-prevalent Neoclassical house type with German-American characteristics while displaying a master designer's sure touch. The Roeser House is listed on the National Register of Historic Places. Photograph made September 1979.

110

Grewell Sod House, Sioux County. Charlie Grewell was the first owner of this substantial one-and-a-half-story sod house, which has a three-room floor plan, an upper floor, and a frame side porch and addition. The house was still occupied at the time this photograph was made in September 1979.

111

Barn, Otoe County.

This early frame barn is in rural Otoe County. Photograph made July 1987.

112

Weddle Sod House, Sioux County. This sprawling five-room sod house was built in about 1907 by Walter J. Weddle for his wife and two daughters. The family sold the house and a section of land in 1917 for $7,200. Photograph made September 1978.

113

Willa Cather House, Red Cloud, Webster County.

Willa Cather lived in this frame house from between the ages of eleven and seventeen. The place figures prominently in her short stories "Best Years" and "Old Mrs. Harris" and her novel *Song of the Lark*. Her international stature as an author and close association with this little building has earned it the status of a National Historic Landmark. Photograph made July 1978.

114

George Cather House, Webster County.

George Cather, farmer, stockman, and uncle of the author Willa Cather, constructed his twenty-two-room farmhouse in numerous stages from the early 1880s through about 1910. This porch appears to date from one of the later additions. The house figures in Willa's Pulitzer Prize–winning novel *One of Ours* and in her short story "A Wagner Matinee." Photograph made July 1978.

115

Wattles House, Omaha, Douglas County.

In 1894 the Omaha architectural firm of Kimball and Walker designed a Chateausque-style brick residence for Gurden W. Wattles, a banker. The towering stair hall is a prominent feature of the interior. Photograph made August 1978.

116

Frank House, Kearney, Buffalo County. See note 14. Photograph made June 1979.

117
Architecture Hall (Old University Library), University of Nebraska–Lincoln, Lancaster County.
See note 105. Photograph made November 1980.

118
Hall County Courthouse, Grand Island.
See note 27. The rotunda, shown here, is topped by the dome shown in no. 27. Photograph made September 1978.

119
Union Pacific Railroad Depot, Gering, Scotts Bluff County.
Photograph made September 1978.

120
Emmanuel Lutheran Church, Dakota City, Dakota County.
See note 19. The church is the property of the Dakota County Historical Society. Photograph made October 1978.

121
Smith Sod House, Sioux County.
Martin L. Smith built this two-room sod house in about 1915. The deep window reveal and the cupboard built into a wall demonstrate the thickness of the sod walls. Photograph made September 1978.

123
Jefferson County Courthouse, Jail Interior, Fairbury.
The old jail in the courthouse, built between 1890 and 1892, has been converted to office space in recent years. The courthouse is listed on the National Register of Historic Places. Photograph made January 1979.

125
Deutsche Evangelische Lutherische St. Johannes Kirche (Saint John's Evangelical Lutheran Church), Burt County.
Built in 1902, this substantial frame Gothic Revival church was designed by J. P. Guth of Omaha, a German-born architect, for a German immigrant congregation. It is one of the finest frame churches in the state, both for the ambitiousness of its scale and detailing and for its remarkable state of preservation. St. John's is listed on the National Register of Historic Places. Photograph made October 1978.

127
Middle Creek Lutheran Church, Highway 34, Seward County.
This small Carpenter Gothic–style church was built in about 1902. It originally had a tall spire. Photograph made April 1979.

129
Landscape, Scotts Bluff County.
Photograph made January 1981.

131
Landscape, Lancaster County.
Photograph made January 1983.

GEOGRAPHICAL INDEX

Composed in Optima type on the

Linotron 202 typesetting machine

at the University of Nebraska Press.

Printed and bound in Hong Kong by

the South China Printing Company,

using 175-line screen duotone onto

157 gsm Matt Art paper stock.

Original photographs printed on

Agfa Portriga-Rapid 111.

Book design by Jungsun Whang.